OTHER TITLES IN THE SERIES

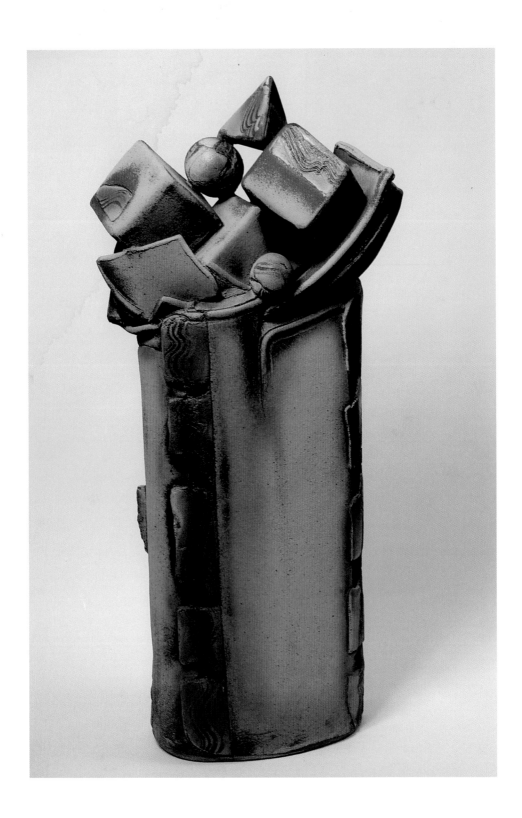

SLAB TECHNIQUES

Jim Robison and Ian Marsh

A & C Black • London

The American Ceramic Society • Ohio

FRONTISPIECE Jim Robison, stoneware sculpture. Ht: 80cm (31½in.).

First published in Great Britain in 2010
A & C Black Publishers Limited
36 Soho Square
London W1D 3QY
www.acblack.com

ISBN 978-1-4081-1007-2

Published simultaneously in the USA by
The American Ceramic Society
600 N. Cleveland Ave, Suite 210
Westerville, Ohio 43082, USA
www.ceramicartsdaily.org

ISBN 978-1-57498-309-8

CIP Catalogue records for this book are available
from the British Library and the US Library of
Congress.

Typeset in 10 on 12.5pt Photina
Book design by Susan McIntyre
Cover design by Sutchinda Thompson

Printed and bound in Singapore.

This book is produced using paper that is made
from wood grown in managed, sustainable forests.
It is natural, renewable and recyclable. The logging
and manufacturing processes conform to the
environmental regulations of the country of origin.

Contents

Dedication

These efforts are dedicated to my long suffering 'potter's moll', wife and author, Liz.

Jim Robison

I would like to dedicate my contribution to my late wife Pauline who encouraged and actively supported me.

Ian Marsh

Acknowledgements

The community of potters is among the most ingenious, practical and generous people you could wish to meet. There is always a discussion of 'how to' or 'what if' when potters get together and their enthusiasm for exchanging information makes the ceramic conferences, festivals, fairs and exhibitions a delight to attend. In fact the desire for give and take of such information is often the motivation for planning activities and the very reason for Potter's Organizations existence. Events such as the annual American NCECA (National Council on Education for the Ceramic Arts) conference, the Welsh bi-annual Aberystwyth international festival, and the Australian Spring Fever and Gulgong events are but a few that could be listed.

Of course, the energy and creativity behind it all resides with the individuals, specific artists and makers, who produce such remarkable work and are willing to share their expertise with the rest of us. We are grateful for all those who have helped to keep the flame of ceramic exploration alive through their knowledge and enthusiasm.

And we wish to thank specifically those remarkable individuals who have so generously contributed images and explanations that helped us to form the basis of this book.

Introduction

Slab-building techniques are among the earliest and most versatile methods of forming clay. At its simplest, little more is involved than taking a piece of clay and pinching it flat in the hand. At a more ambitious level, a lump of clay can be pressed out underfoot or spread out by hand. Mechanical aids in the form of cutting wires, rolling pins and slab-rollers permit an increase in scale and precision, yet the freedom of expression attainable through slab techniques remains a unique and personal one.

In this book, we felt particularly keen to include as many techniques and methods as we could. All too often ceramic texts suggest a particular method of joining slabs as though there is only one definitive way. We offer several methods of making slabs, building and creating forms with them; surface treatments to enrich visual potency; and advice on glazing and firing to achieve the desired results. Our hope is that this book successfully lays out several techniques, leaving it to the individual to choose the one that suits his or her clay, environment and temperament best. Improvisation and experimentation are essential to growth, and mistakes are important steps to knowledge. Providing solutions to problems encountered during the making process may allow the maker to move beyond a focus on technique alone and find a greater freedom of expression.

Ian and I have worked together on a variety of projects for over eight years now. We share a passion for ceramics – the making, the processes and the associated problems. We have also enjoyed the challenges of teaching and have recognised a need for a volume relating to slab techniques. Initially reluctant to begin such a project, once we started we found it an interesting and exciting adventure, particularly in meeting and talking to the artist-potters about their work. They have been extremely generous with their help, and their enthusiastic support has been infectious. Francis Lambe went so far as to say 'makers who publish are vital for promoting ceramic practice'. We thank all of them and hope this book proves to be a useful addition to this end.

In creating this book we followed our editor's advice to have one voice for the text, so you will hear the voice of Jim Robison throughout. We jointly created an outline for the content and planned the images to illustrate the text. Ian took onboard the task of contacting the artists and co-ordinating many of the making images as well as taking innumerable photographs. Regular discussions were held about content with editing and compilation undertaken as a joint effort. We very much hope you enjoy the results of this collaboration.

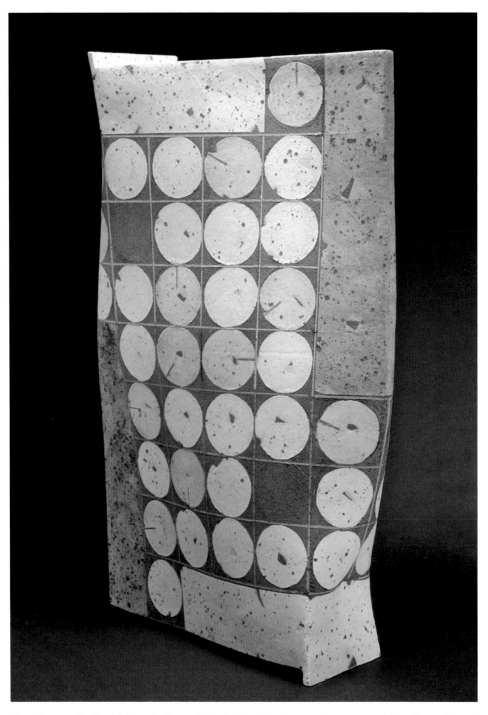

Time Zone by Regina Heinz, Ht: 60 cm (24 in.), this slab piece explores geometric patterns. *Photo: Alfred Petri.*

Chapter 1
The Clay

Starting out

Potters have an affinity with a sticky, malleable material which is a nuisance underfoot but ever so useful in the hand. Initial experience might be in childhood, playing with the stuff along a stream bank or pinching out some object or image in a classroom.

A fortunate few have been inspired by creative teaching or perhaps developed their skills through direct contact with the clay in a studio or workshop environment.

Wherever or whenever it happens, there is a certain pleasure that comes in the handling of materials and the assembling of ideas into something tangible and tactile.

In the beginning, there is seldom an underlying understanding of the clay, simply a response to the material at hand. Whatever we are given to hold, development begins and grows from this contact. The clay might be smooth and sticky and very plastic or mouldable; or it might be rough to the touch, full of sand or grog, and have a tendency to crack when stretched into shapes. The hands are the first line of response, and judgements are made; enthusiasms develop from this contact. Further down the line, we still require a touch to determine texture and plasticity, according to personal preference, in the clay we buy to use.

Fortunately, most clays will have enough shared characteristics to allow modelling, throwing on a potter's wheel, and making items using handbuilding or slabware techniques. However, with more experience you begin to choose clay on the basis of how it behaves as well as for how good it feels.

Smooth clays

Soft fine-particle plastic clay is very comfortable in use and appropriate for smaller items. On the potter's wheel, when water is added and pressure applied, it changes shape relatively easily, remaining smooth to the touch throughout the forming process. It also lends itself to fine details and delicate hand-modelling. In slabware, its plasticity means that slabs can be bent, pinched and pushed into all sorts of shapes. Surface textures and patterns are easy to apply, and the smooth clay will also be easy to burnish or finish to a high degree. When wet, or leatherhard, joining sections together can be accomplished with nothing more complicated than a bit of scoring and clay slip. It is wonderful. Problems are most likely to emerge when larger and more complex items are attempted.

Plasticity

Although essential, too much plasticity means that slabs can be floppy and difficult to control. Using clay that is a

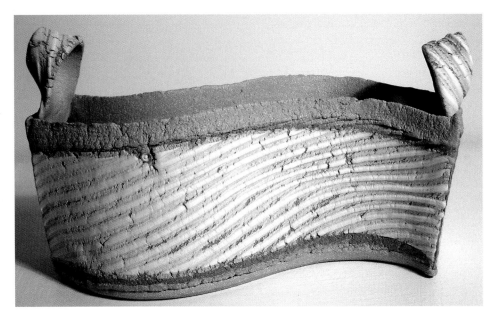

Ripple Vessel by Jo Connell. W: 35 cm (14 in.). Jo Connell explores the nature of the material using a mix of coloured clays. *Photo: courtesy of the artist.*

Regina Heinz dries slabs to leatherhard on paper supports.

bit stiff will help. Moreover, there is less inbuilt stability in very plastic clays, which will also have greater shrinkage that needs to be allowed for. You soon discover that gravity is not your friend, and supports will be needed to hold the clay in shape while wet. These act as resting places while the clay begins to dry. Individual sections are often made and then allowed partially to dry, so that they stiffen to a leather-like hardness before assembly is attempted.

Shrinkage

Shrinkage is a potter's problem. Fine plastic clay has a much greater shrinkage than its rougher counterparts. At one extreme, the fine ball clays and porcelain bodies will contract by as much as 20%. This means that great stresses and distortions are created in the drying and firing cycles. If drying is rapid or uneven, then cracks may well appear.

Coarse clays have substantially less shrinkage, and the addition of grogs and sand will reduce this even further. Total 'wet to fired' shrinkage for many of the handbuilding clays on the market is around the 10% mark, with about half of this loss occurring from the initial 'wet to bone dry' phase of the making. It is easy to see why joints must be carefully made. And for best results it is best to dry pieces as slowly as is possible.

Fresh slabs intended for construction may be dried to some extent on absorbent boards, paper or cloth prior to use, but any bending and stretching must be done while the clay is still quite wet. Placing completed and firm work on slats will allow air to circulate and reduce unevenness in drying. During firing, the use of a placing powder (calcined china

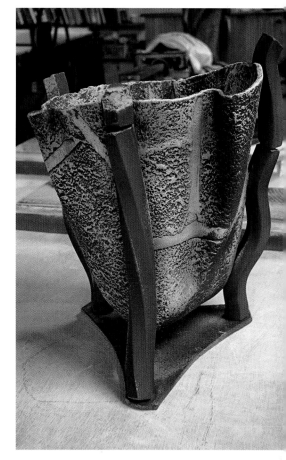

Jim Robison's tripod work is fired on a sheet of clay to accommodate shrinkage. Ht: 45 cm (18 in.). *Photo: Jim Robison.*

clay, grog or silica sand) on kiln shelves may also ease movements at the base of any work. In some cases, the work is placed on another piece of clay for support during firing. This will shrink at the same rate and greatly reduce stresses on the object above. The legs of my tripod vase were prone to cracking away from the body of the pot. To eliminate this problem, a slab was placed under the piece. This shrinks at the same rate as the pot and prevents the legs from sticking to the kiln shelves. Problem solved!

Coarse clay for larger items

Several things can help overcome excessive plasticity and reduce shrinkage. The clay mix itself may be formulated to contain rather larger-grained fire clays. Sand or grog (granular fired-clay particles) may be added for additional strength. These rigid materials and larger particles restrict movement but greatly aid stability. In practice, clays are formulated as a compromise between smooth plastic qualities and coarse strength, and a thorough read-through of the manufacturer's description is essential. Grog is graded according to mesh size, the smaller sizes being the higher-number mesh. For example, 120 to dust is very fine and suitable for dinnerware. A 60 to 80 mesh would be a larger size, more appropriate for handbuilding clay. Clay for the production of bricks and clay pipes, where plasticity is not so crucial, will often have substantial amounts of shale and crushed fired shards, which are recycled as grog.

Mixes can vary from 5 or 10% to as much as 50% grog additions. An overload may provide a strong body but allow very little flexibility during the making stage. This is considered a 'short' body and is prone to cracking when bent or flexed. Of course the only real test is to try some, and to this end most manufacturers are happy to provide samples at a modest cost; alternatively, simply 'ask a friend', as they say. As a general rule of thumb, it would seem that the finer the clay, the smaller the objects that are easily created.

Nigel Hoyle's dramatic porcelain slip over a stoneware surface. Ht: 60 cm (24 in.). *Photo: courtesy of the artist.*

Nigel Hoyle illustrates the dramatic shrinkage from liquid slip to stoneware in an unusual way. Porcelain slip is poured over a fired, glazed stoneware surface. This is re-fired with additional glazing for a dramatic cracked effect.

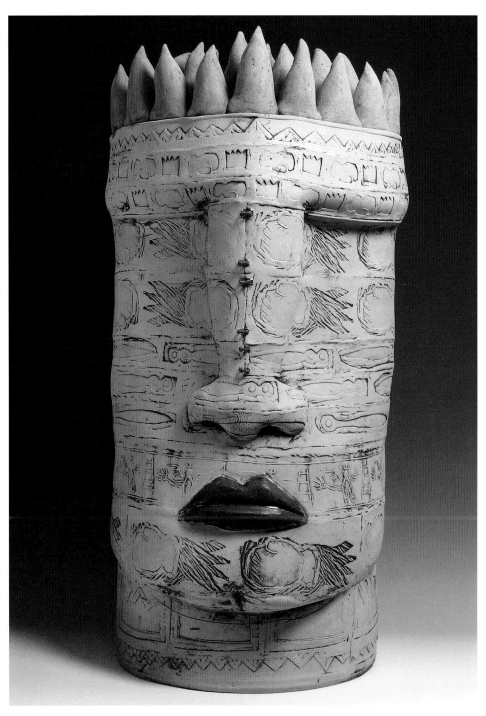

Prize Fighter by Paul Wandless. Ht: 65 cm (26 in.). This dramatic head has a block printed texture. *Photo: courtesy of the artist.*

Porcelain

Porcelain is a special case and requires particular care in practice. This body is a combination of plastic, white ball clay and relatively coarse china clay mixed with non-plastic materials such as silica and feldspars. These mixes are very fine and smooth to the touch. Most have a very high shrinkage rate, perhaps as much as 20%. Another much-sought-after characteristic of porcelain is translucency. This requires a fairly complete fusion of material at a high temperature; so to achieve that glasslike quality, pieces reach a near-fluid state in the kiln. As you can imagine, manipulations by hand, uneven thickness, joints and seams all create potential problem areas. If pieces are not carefully made, imperfections and stresses are likely to show up as distortions and cracks. To strengthen the porcelain for handbuilding purposes, white china clay grog (molochite) may be added. This pre-fired material will maintain the clay's whiteness while reducing shrinkage to a significant extent. It is important to note that there may be some sacrifice in translucency when added in quantity. However, much handbuilt work is fairly thick and opaque, so colour

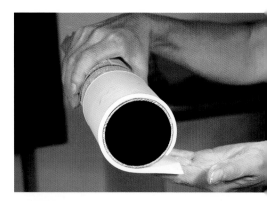

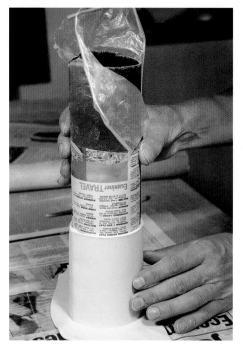

RIGHT, TOP TO BOTTOM

Soft porcelain is wrapped around the tube and joined by gentle pressing. When the clay is fresh, Alison Campbell finds that no slip or water is needed.

Alison Campbell uses a plastic tube wrapped in plastic and paper to support porcelain cups in the making. Paper and plastic mean that the tube is easy to remove after joining.

Alison Campbell joins the base to the rim.
Photos: Ian Marsh.

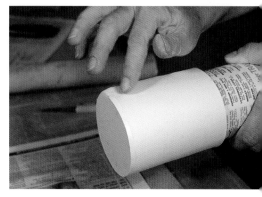

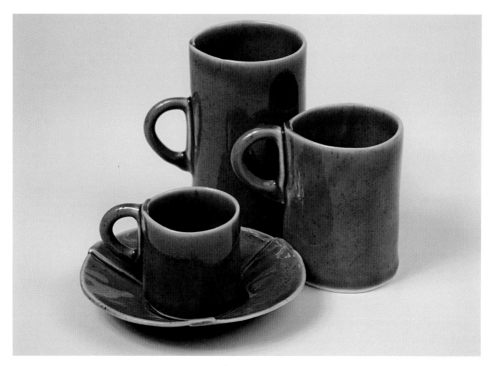

Alison Campbell's porcelain cups and saucer. *Photo: Ian Marsh.*

rather than translucency is the most important element.

Paper/fibre clay

In recent years, the problems of strength versus plasticity have been helped greatly by adding paper or other fibres to the clay. Simple formulae of about 10% newspaper or toilet paper and water added to a bucket of clay slip can be blended in a bucket with a mixer paddle on an electric drill. When dried out on a plaster slab, the fibre clay can be wedged and used as plastic clay with great strength relative to its thickness. Irish potter Jim Turner is a great exponent of this clay, taking advantage of its characteristics to create highly textured and painted surfaces.

Some potters prime the plaster bat with colours or printed slips before spreading out the paper-clay slip. When dried to the right consistency, this will make a ready-to-use, pre-decorated slab for construction purposes. Slabs may be dried and re-wet for use without any problems.

One additional advantage of fibre clay, I have found, is its ability to repair cracks which have appeared during drying of work made from normal clays. For best results wet the edges and work fibre clay deep into the crack. It is worth a try even on bisque ware.

One drawback with paper clay is its tendency to smell when stored for some time. This can be corrected to a large extent by the addition of small amounts of Milton steriliser or bleach to the mix. Nylon, flax and other fibres have also been introduced to clay bodies with considerable success. If time is an issue,

ready-made bodies are now available from clay manufacturers. They give strength without the smell, and bind the clay structure together during drying. These fibres or bits of paper burn out during firing so that the essential clay form remains. (Remember that excessive additions may weaken the fired body.) The fibre-clay pieces may be glazed in the same way as any other ceramic object.

Colour and textures

Fine clays with very little grog content will give by far the smoothest surface. As such they are appropriate for glaze decoration, burnishing or other smooth details. Coarse textures may be achieved by simply scraping the surface of a grogged body with a metal kidney. The size of the grog or sand and the direction of the pull on the kidney will determine the size of the mark created. Additional grog or larger particles may be wedged into the clay for a more pronounced texture. Garden-centre materials such as vermiculite and perlite have been used to good effect. Some combustible materials, such as seeds or sawdust, can be added or simply rolled into the surface to create variations in texture. Indeed, any combination of fibres and other materials might be worth a try. My wife recoiled in disgust when cat food (dried star shapes) was rolled into one slab, but as all organic material burns out on firing, the finished item had a great cratered surface and, of course, no smell at all.

Stains and oxides can be wedged into the clay to alter its colour. Amounts of

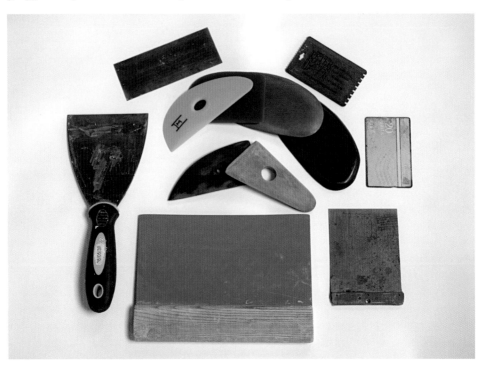

A variety of metal, plastic and rubber kidneys and scrapers will be useful to smooth and shape the clay.

16

Wendy Lawrence carved into highly grogged clay for this standing piece. Additional texture was provided by a silicon carbide glaze. Ht: 60 cm (24 in.). *Photo: courtesy of the artist.*

John Higgins uses texture and colour to good effect. Ht: 30 cm (12 in.). *Photo: courtesy of the artist.*

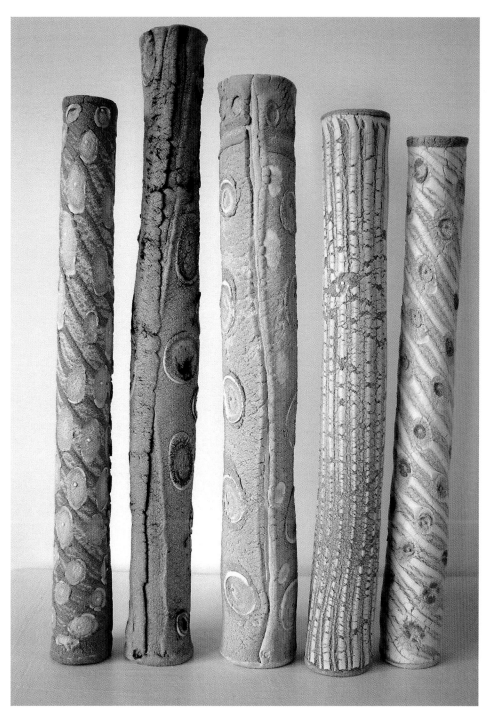

Jo Connell uses coloured clays to dramatic effect on these simple textured tubes. Ht: 30–40 cm (12–16 in.). *Photo: courtesy of the artist.*

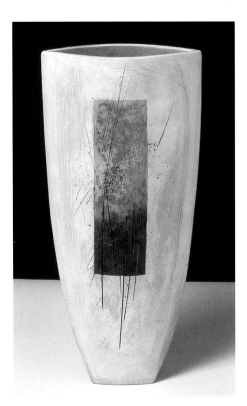

Autumn Vessel by Tessa Wolfe Murray features subtle marks and isolated colour shapes. Ht: approx. 30 cm (12 in.). *Photo: courtesy of the artist.*

Probably the most effective way to achieve a good colour mix is to create a slip from the clay body before adding the colour. Colours can then be blended in water and stirred into the mix. The slurry will then need to be dried to a plastic consistency before use.

Those with a specific interest in this subject should refer to Jo Connell's book *Colouring Clay*, also published by A&C Black.

Personal choice

Personality and individual preferences also play their part. Coarse rough clay may be better for the big bold statements, which require sweeping arm gestures in their creation. Fine smooth clay will suit the more careful and precise movements made by the fingertips. Preferences as to textures and surfaces need to be explored to be discovered. Your hands in making will feel the qualities of a particular clay, and the type of surface obtainable will vary greatly from one clay to the next. Additions of fired grog particles make polished edges more difficult to achieve, yet the same material does reduce possible warping and distortions of form. Large pieces are generally easier to make with grogged clays. Smaller works, clear mark-making and careful edges might be best obtained by using smoother clay, and there is also the matter of fired colour to consider. In the end, these choices are individual ones, and our own personal preferences will play a crucial role when choosing which clay and working methods best suit our purposes.

oxide can vary from 2 to 10% or more, but you should always test small amounts of clay and colour first. Until you test the mixes in your own kiln and firing conditions, the results will be unpredictable. In fact, colours and oxides may act as flux within the clay body, and excessive amounts may cause bloating in the piece.

Dry colourants are added to a bit of water before being worked into the plastic clay. Holes are sometimes poked into the soft clay, and the colour poured into them before wedging. It is a rather messy and laborious process.

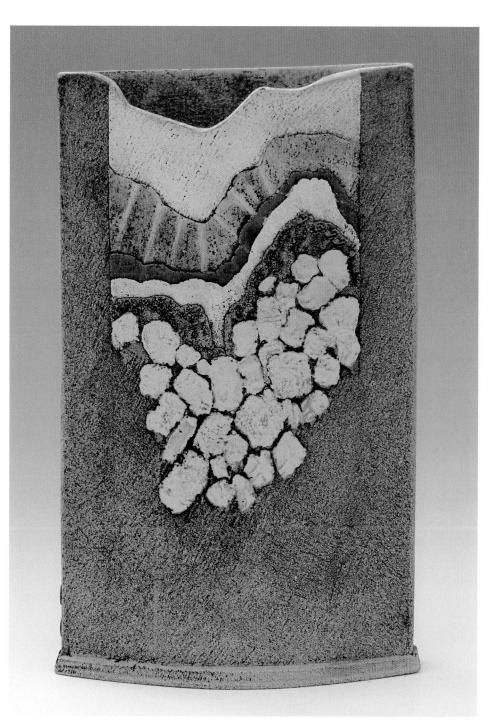

Nigel Edmondson uses coloured clays and oxides without glaze for his stoneware garden pieces. Ht: 40 cm (16 in.). *Photo: courtesy of the artist.*

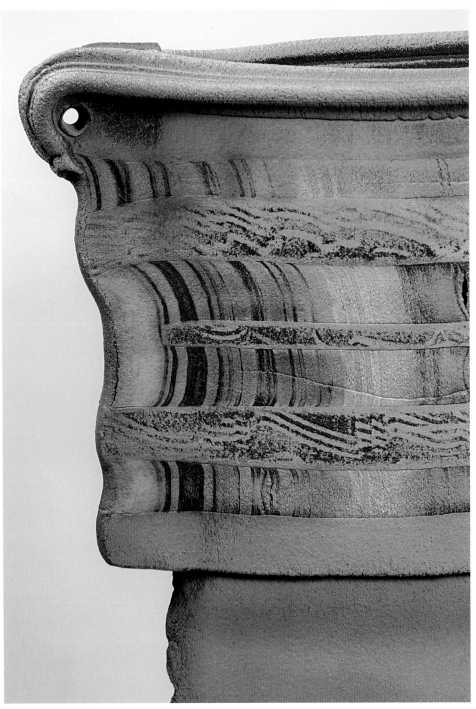

A detail of slip-decorated strips rolled into the slab on this vase by Jim Robison. Ht: 1.2 m (4 ft). *Photo: Ian Marsh.*

Chapter 2

Making the Slab

Regardless of how a slab is created, the condition of the clay is the first consideration.

Ideal clay is one that has enough moisture and plasticity to allow easy movement for rolling out while being sufficiently stiff to hold its basic shape as it is being moved around. It also needs to be free from air pockets that will cause trouble later on.

Purchased clay is often either too wet or too dry for comfortable use. Sticky wet clay will need to be dried out to some extent prior to use. This can be done by simply leaving out the clay in a warm space for a while, drying it on absorbent boards and bats or making large slugs which are bent into inverted U shapes so that air can circulate around the mix.

Clay that is too dry is more of a problem. It is hard to cut and difficult to roll out, although if you can manage these tasks, its stiffness makes the rolled slab somewhat easier for making and assembling pieces. In those instances where moisture needs to be added to make the clay workable, it is worth mentioning that coarse grogged clays are more 'open' and will take up additional water much more readily than a fine, dense clay body.

If clay is quite stiff, some makers advocate drying it out completely, then creating a slop or slurry by adding water before drying it out again to a more workable consistency. Dry clay will break down readily and will therefore absorb the water more easily. If the clay is very dry, this may well be the only solution. Essentially, you are remaking the clay body.

If bags of clay are just stiff but still quite wet, then water can be worked into the body or allowed to soak in over a period of time. The block can be cut into bread-like slices with a strong wire, each piece being dipped or soaked before the 'loaf' is reassembled. Let the shine go off – a sign that the water has been absorbed – and then wedge it back into a softer mix. Sometimes just adding small amounts of water to the clay bag and leaving it for a day will help. Repeated spraying and wrapping of the clay in damp cloth and plastic could also do the trick.

Wedging/kneading the clay

Once you have achieved the right moisture content, the clay should be wedged to create a uniform consistency. There are several methods of wedging or mixing the clay. The first involves wire-cutting the mound of clay in two, then lifting and rotating one section before banging them together, giving the air plenty of opportunity to escape from the mixture. Several repetitions are necessary for a good mixing. The other two methods of hand-mixing are described as ox-head wedging and spiral wedging, both named for the shapes

created in the process.

Ox-head wedging utilises both hands applying downward pressure in a uniform rocking motion on the outer ends of the clay mound. The whole block is regularly rotated to vary the position of the hands until the entire mound is mixed.

Spiral wedging uses one hand to push downward with repeat motions, while the other hand rocks the mound and rotates it to feed fresh clay into the process. Although you are only applying pressure to a small section of clay, the rhythm of the process soon mixes the entire rotating mass into one uniform consistency.

To monitor the success of your wedging, periodically draw a wire through the mound and check for air pockets. Do not mistake marks where the wire drags grog across the surface for air holes. If air holes are visible, continue the wedging process a while longer. Air should cause concern, as it may allow pockets of steam to develop during firing. If the firing is rapid, or pieces are damp, trapped steam may cause dramatic explosions in the kiln. My own experience suggests the more open and grogged the clay body is, the less of a problem steam becomes. Just as this clay will absorb water quickly, it will also allow it to escape more readily. It is also important to dry the work thoroughly prior to firing and to take the initial warming stages quite slowly. In my own case, several hours are devoted to an initial warming cycle approaching the 100°C (212°F) mark. With larger works, the kiln is put on a very low setting overnight. Impatience is much more of a problem than air pockets in the clay.

Hand-wedging is fine for a small amount of clay, but for larger mixes a clay mixer and pug mill are of great help. Some of the modern machines combine both mixing and pugging features in a very efficient action. This means that clays of differing consistencies (from slops to leatherhard pieces) can be put in the machine and blended for use. De-airing is another optional feature in some machines. Clay that has been through a de-airing pug mill has advantages. The vacuum pump compresses the clay during pugging, increasing its density and strength as well as rendering it free from air pockets.

Slab-making

Rolling by hand is the most common method of creating small slabs. UK potter Nigel Edmondson hand-rolls his slabs for even the largest sculptures. Using a rolling pin, wire-cut or press out a layer of clay a bit thicker than the desired slab. The recommended method is to use a cloth or an absorbent board for this purpose, to avoid the slab getting stuck to the table. Slats of the desired thickness are placed on each side of the clay before the rolling pin is used to stretch the clay into its desired shape. It will help to rotate or flip over the clay regularly, to free it from its baseboard or cloth and allow it to stretch evenly on both sides.

Clay may also be pounded out by hand or with a mallet into a slab shape. Guides are placed along each side, and the top layer scraped off or wire-cut to remove any excess clay. This leaves a slab that has little directional stress, due to the lack of stretching that occurs during rolling out. Industrial users may build up a huge block of clay from which to cut slabs. Tightly compacted with a mallet, perhaps chest high, and contained within an

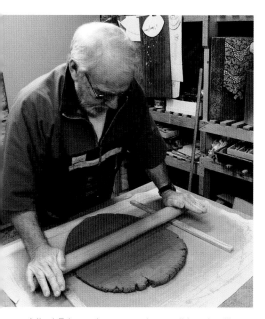

Nigel Edmondson uses the traditional rolling pin to make his slabs.

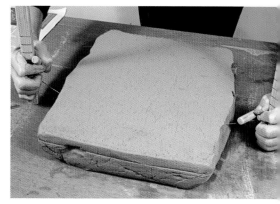

Karin Hessenberg uses a wire and notched sticks to cut slabs of specific thicknesses.

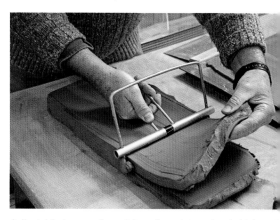

Adjustable harps allow slabs of predetermined thickness to be cut from the block.

angle-iron framework, this block is then sliced into large slabs by drawing a strong wire through the block along adjustable guides fixed to its sides.

Karin Hessenberg uses notched sticks and a simple wire to cut clay sheets of identical thickness for construction purposes. It is worth mentioning that the wire will create its own texture as it pulls the grog while passing through the block of clay. It is well worth experimenting with various wires, stretched springs and knotted cords to create different surface marks and textures. These fresh surfaces can be very exciting.

Smaller clay slabs may be cut into shape with a wire harp, directly out of the bag. However, even if so cut, it is usually best to roll the clay as well, to compress it for greater strength. This will ensure its particles stay together when you handle the slab. If you do not do this, there is a great chance that the slab will open up in fractures as it is handled.

Slab rollers are a great help if you are making slabs in any great numbers. They will provide uniform sheets of clay and are a great labour-saving device. They come in a variety of shapes and sizes. North Star Equipment Inc. provides everything from small portable sizes up to those with a whopping 91.5 cm (36 in.) diameter. The choice of which to buy is really determined by the scale of the work you make and perhaps the space available. Most are essentially of two types: one having a single large roller

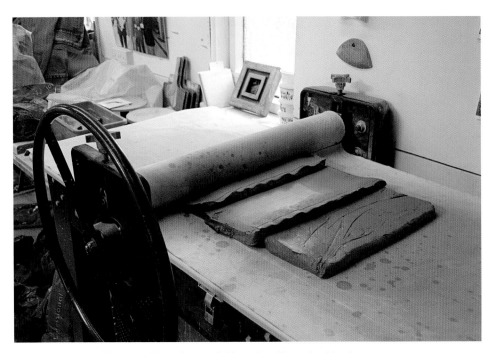

North Star 76 cm/30 in. double-roller model in action. *Photo: Ian Marsh.*

that passes over the clay, and the other having two rollers that pass the clay between them. The first sees the roller move down the table, and the second requires the clay to move while the rollers stay fixed in position on the table.

Large slabs can be created from several pieces of clay. I cut slabs slightly thicker than needed. These are tapered on the leading edge, overlapped and then compressed by the roller pressure (see image above). Care must be taken not to place too much stress on the machine. If slabs are too thick, rollers are difficult to turn and damaged gears or cables will be the result. With some machines, it will be necessary to gradually thin the slabs by passing the clay through several times.

The single-roller models usually travel the length of a strong table or bed, compressing and forcing the clay into a slab as it goes. The thickness of the slab is determined by the gap between the roller and the bed. This gap is adjustable by the removal or addition of thin boards lying on the bed. A cloth is used to prevent the clay from sticking to the board, while another cloth is placed over the clay to prevent the roller from sticking to it. While strong and robust, the difficulty in using this type of roller is simply the lack of fine adjustment, or indeed any adjustment when the clay is on the table. The rollers are supplied with a stock of boards in different thicknesses, some of which you need to remove when thicker slabs are being made. Storage and handling of these table-sized boards can also be problematic.

The double-roller model is similar in action to the old wringer washing machines and some printing presses. They pass the clay between them and in doing so transform the thick material

Chris Jenkins's thrown cylinder is cut up and converted into slab vessels. *Photo: Ian Marsh.*

into a thin sheet. Once again, cloths are used under and over the clay so that it does not stick to the rollers. Some potters place the base cloth and clay on a thin board to carry the clay and cloth together through the rollers. The rolled slab is then already on a support board when you wish to pick it up. Simple knobs or handles adjust the space between the rollers so that thickness is infinitely controllable. Some models can be adjusted at each end of the rollers, allowing you to create a tapered slab.

After rolling out the slab, the cloths are removed to release the clay. Removing the clay from the bottom cloth is best done by flipping over the whole slab, complete with cloth, onto another board. The base cloth can then be peeled back without leaving finger marks on the clay, and without the risk of stretching or tearing it in any way.

Alternative methods

Throwing

Clay slabs are sometimes created in other ways. Chris Jenkins and others use the potter's wheel as their basic tool. Rather than roll the clay, a substantial cylinder is thrown on a bat, often with a minimal base or entirely without a base. This is allowed to dry to a soft leatherhard stage, cut from the bat and vertically sliced. This cut cylinder is then opened out to form a slab, and the finger ridges are either smoothed out or kept as a feature of the surface. A separate slab is made for the base.

Extruding

Other potters use an extruder – producing a strip, cylinder or tube, for example – to make the basic shape. The strips are thin slabs that may be used in the

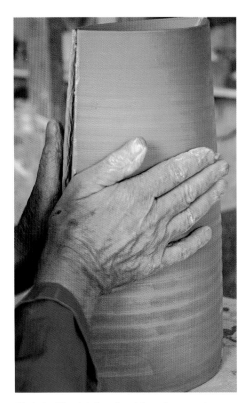

Chris Jenkins joining the sides of a vessel. Using the heel of the hand avoids leaving finger marks. *Photo: Ian Marsh.*

construction of larger pieces. When one strip is not large enough, a die could be made with tapered edges to allow strips to overlap and be securely joined to make a larger slab. Extruded cylinders can be opened up, just like their thrown counterparts, to create flat sheets of clay; of uniform thickness and compressed by the extrusion process, their size is limited only by the diameter of the extruder itself and the length of the clay tube.

Coils and strips

Coils or pellets of clay can be joined together to form larger slabs or sections of a piece. Side walls are built up from pieces of clay pressed out between the fingers, a small section at a time. A number of potters, including John Ward, create slab-like vessels by joining overlapping coils together. Perhaps this group should be called pinch or coil pots, but as the overall intention would seem to be the creation of a relatively flat side wall, it seems pointless to quibble over details. Slabs themselves are often joined by coils, or form parts of thrown pieces, or are pressed and coaxed into

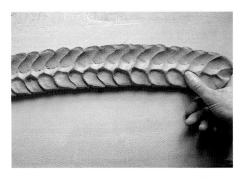

BELOW John Ward presses and scrapes coils into a slab for building.

RIGHT John Ward assembles pre-shaped slabs. Note the shape of the next section, drying on the table.

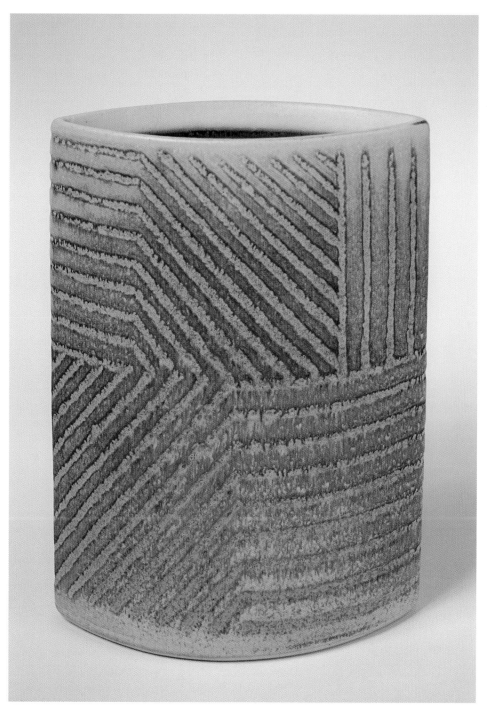

Chris Jenkins's incised vase has sides created from a thrown cylinder. Ht: approx. 30 cm (12 in.).
Photo: Jim Robison.

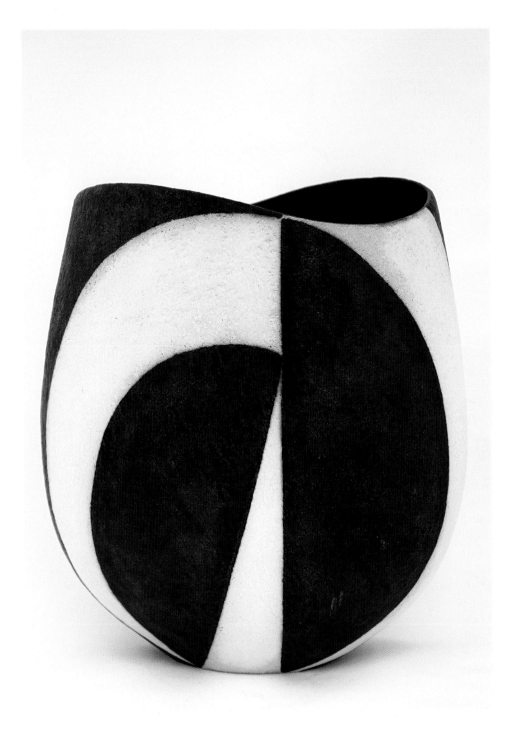

John Ward used flattened coils to shape this black and white pot. Ht: approx. 25 cm (10 in.).
Photo: courtesy of the artist.

Slab by Frances Lambe. L: 95 cm (37 in.). Frances Lambe creates natural forms through combinations of pinched-coil and slab constructions. *Photo: John Kelly.*

shape between the fingers; whatever the emphasis, there is always room for variation on a theme.

The slab is not an isolated ingredient, so it is important to view it in conjunction with all other forming techniques. Coils are not just for reinforcements, but may be used to build up sections of a piece. For example, Francis Lambe adds coils to create wonderful undulating surfaces on top of her box constructions.

Slip/slurry

Slip or clay slurry can be used to cast a slab on a plaster bat. This is particularly useful when the clay is being mixed with other ingredients, such as paper fibres or colour. Irish potter Jim Turner uses vast quantities of slurry to create fascinating slabs. Textures, marks and all manner of printing and painting techniques are applied before the slab is used for construction or other purposes.

Jim Turner applies texture to a slurry of paper clay. *Photo: courtesy of the artist.*

A number of potters have popularised the technique of printing by applying colours to the plaster bat first. When slip or a slab is applied to this image, the colour is picked up and becomes a part of the slab. The printed slab then becomes part of a larger object.

Jim Turner's brightly coloured fibre-clay vessel. Ht: approx. 60 cm (24 in.). *Photo: courtesy of the artist.*

Chapter 3

Construction Techniques

First consider what you wish to create. Planning can be assisted by drawing, by external stimulus (objects, patterns in nature, other pots or sculptures) and by previous experience. Paper patterns can be useful. I consider a slab to be similar to a piece of paper or flexible card. When soft it can be as flexible as a piece of cloth, and can be folded and shaped in many directions; slab-building might be described as being similar to dressmaking. When slightly firmer, the sheet becomes more stubborn and only wants to bend in one direction, although with a bit of pressure and gentle stroking it can still be stretched and gradually coaxed into more organic shapes. When dried to stiff leatherhard, the clay is more akin to a sheet of plywood. Rigid enough to stand upright, it is strong enough to support its own weight. Wet and score the edges, apply some slip, and pieces can be joined or 'glued' together.

Roger Lewis begins with a sandwich of two soft slabs for each side. Having joined them at the edges, he inflates them by blowing through a straw along one seam. The pillow form is then impressed

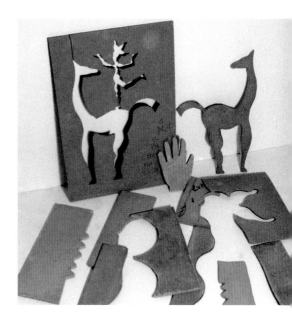

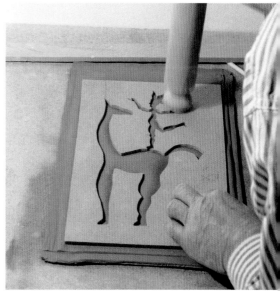

RIGHT Roger Lewis constructs his *Horse and Juggler* pot using cut-out wooden templates.

Two slabs, pressed together at the edges, are inflated with a soda straw to make a cushion. A cut stencil is pressed against this soft, inflated cushion of clay. *Photos: Roger Lewis.*

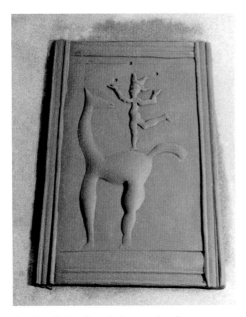

A soft relief surface is the result of pressure on the wood stencil.

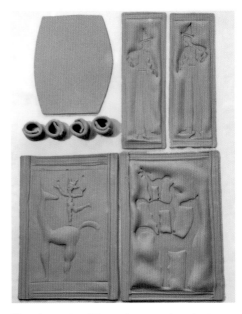

The elements of the pot are made prior to assembly.

with wood templates to create the images in relief. When leatherhard, the sides are joined together and a rim and feet are added. Push a needle into the inflated area, allowing steam to escape during firing.

Softness and flexibility are largely controlled by the amount of water in the clay, and control of this softness, or moisture content, is very important. Add the element of shrinkage during drying and it becomes essential to manage moisture content all the way through the making process.

Weight and gravity also influence the form during this building process. How the clay handles depends largely upon the amount of moisture in it. In other words, a freshly cut or rolled slab will be wet, soft and therefore floppy when picked up. Easily textured and impressed at this stage, a slab left to dry will become firm and rigid at the bone-dry stage. And in between these two extremes

there are varying stages of flexibility, called leatherhard, where most slab construction takes place.

Soft slabs

When the slab is first prepared, it is generally best to resist picking it up by its edges, as at this stage it is prone to stretching and distortion. Even when laid down again, the slab has a tendency to remember this change of shape, and will try to recreate it during the drying cycle.

When rolled out, the slab often sticks to the cloth or other surface, and may resist being picked up at all. The solution is to peel the cloth from the clay rather than try to pick the clay from the cloth. If you sandwich the clay and cloth between boards, and turn them over as one, the cloth can easily be removed from the clay without distortion of the slab. A paper sheet placed on the slab before it is turned

Partially assembled work supported on battens until firm.

RIGHT Roger Lewis's *Horse and Juggler* contains inflated relief surfaces. Ht: approx. 35 cm (13³/₄ in.). *Photos: Roger Lewis.*

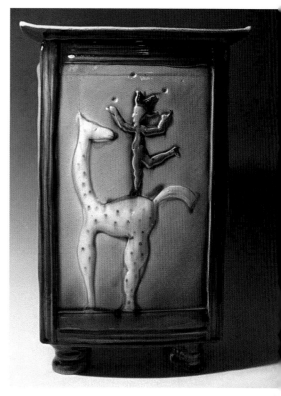

over onto another board will assist drying and allow movement of the slab from one place to another. I use brown wrapping/parcel paper when available, as this resists tearing and comes off in one piece, even when wet.

It is best to make all the slabs for a piece at the same time so that they contain similar amounts of moisture throughout assembly. When you are in production mode, it is useful to be able to stack the slabs one on top of another until they are ready for use. Layers of paper will prevent them from sticking together.

Just one cautionary note: if left for an extended period of many days, newspaper will soften to the point of disintegration, go mouldy, and need to be scraped off with a metal kidney. This is the last thing you need when you are finally trying to get going.

Supports and moulds

With simple slump or hump moulds, bowls, dishes or shell-like shapes are possible. We get pleasure out of a simple drop technique. Place the soft slab over a wooden dish mould, similar to a picture frame (see opposite). Place the frame and clay on a supporting board and drop it from waist height onto the floor. Its own weight and gravity will force the slab into the mould on impact (with a satisfying bang). This method allows very wet slabs to be instantly shaped into bowls or plates without the surface of the clay being touched or smudged. This is helpful when slip decoration has been applied.

Clay may be pressed into a plaster mould or draped over a plaster dome (a hump mould) at this stage. Plaster has

35

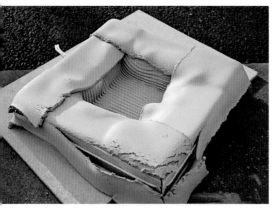

ABOVE LEFT Wooden frames of varying sizes make useful moulds.

ABOVE RIGHT Ian Marsh constructs a dish by use of a wood frame. Soft slabs are overlapped.

LEFT Slabs join securely and take on pleasing contours when dropped from waist height (note supporting board placed underneath first).

BELOW Ian Marsh's dropped dish has taken the shape of the wooden frame. Dia: approx. 30 cm (11¾ in.) square. *Photos: Ian Marsh.*

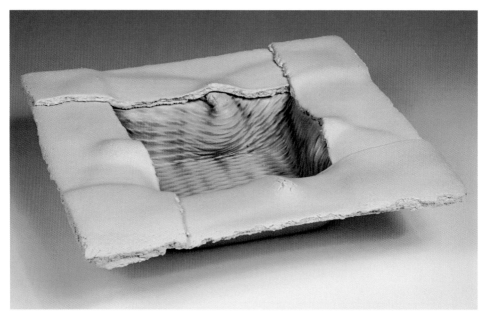

the advantage of drying out the clay and bringing it into firm stage sooner than would otherwise be possible. Shrinkage means that clay drops out of the mould, or it may be lifted off when firm.

Bisque-fired shapes can perform a similar function. Absorbent and fairly strong, they also have less weight than a block of plaster. My studio has several of these 'bowl' moulds created in a Chinese wok. Slabs may be curved and pushed into this shape, dried out and fired. One advantage of using the hump or outer side of the mould is that it is possible

TOP RIGHT A Jim Robison slab dish inverted over a bisque mould while supporting feet are attached.

RIGHT Nigel Edmondson's pieces are made over the exterior of two bisque moulds. Soft coils and slip join the inverted pieces together whilst supported by the bisque mould.

BELOW Nigel's refinement takes place in the bisque mould. *Photos: courtesy of the artist.*

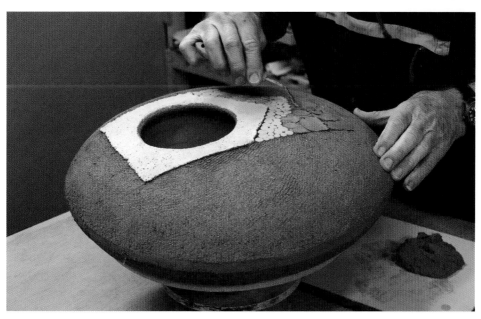

to add feet and work on the base of the bowl at this time. The interior of the bowl remains pressed against the mould and is protected from distortion or the smudging of any applied decoration.

If you wish to take advantage of lightweight moulds, simple plastic forms are sometimes available in appropriate shapes. Old lampshades, bowls and other found objects may be used. (Glass ones are also viable, but remember that these are easily broken and therefore risky to use.) Easy to lift, these shapes may be flipped over as necessary to remove work from inside the mould or to gain access to the other side of the piece.

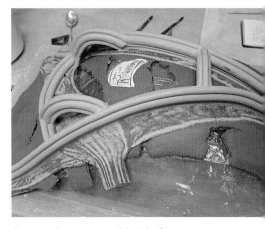

A plastic form covered in thin film prevents sticking.

You might find access to vacuum-forming at a nearby college. With this equipment, I had several thin plastic shapes made around bisque-fired bowls. These plastic moulds, aside from being lightweight, will sit inside each other, making for easy storage when not in use. Plastic is non-absorbent, of course,

Jim Robison uses a stretched slab to create this dish below. (Detail, right.) *Photo: Jim Robison.*

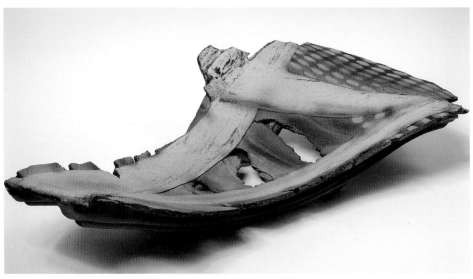

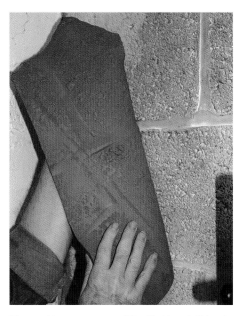

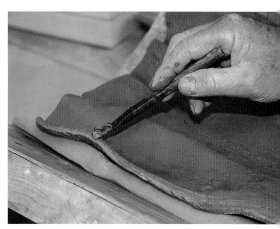

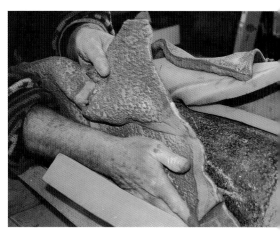

The making sequence of Jim Robison's *Tripod*.

CLOCKWISE, FROM ABOVE

A slab thrown against a textured wall.

Scoring the seams.

Joining the sides together. Add soft coils along seams for strength.

Closing the base.

Re-texturing the seams. *Photos: Ian Marsh.*

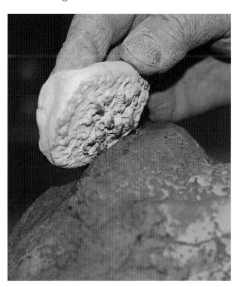

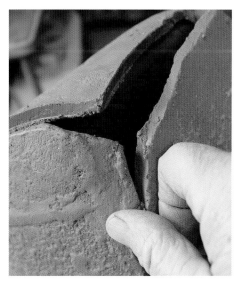

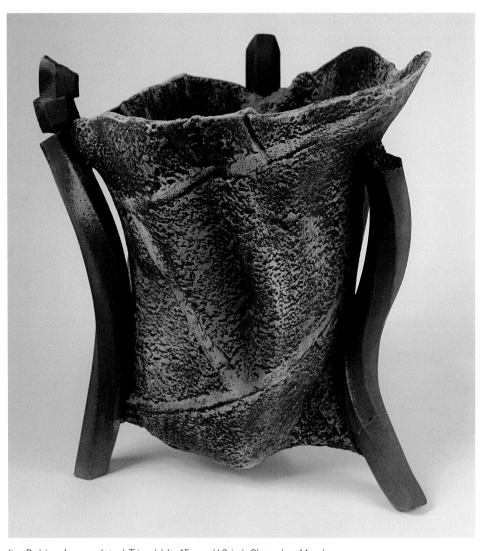

Jim Robison's completed *Tripod*. Ht: 45 cm (18 in.). *Photo: Ian Marsh.*

and wet clay will stick to its surface. To prevent this from happening, lay a piece of cling film (plastic kitchen wrap) on the slab before placing it on the plastic mould. The clay can then be easily removed when firm. This film will also give protection to any painted patterns you have applied to the clay as you adjust it in or on the mould. It will also slow down the drying process.

If a complex shape is desired, for best results use clay at a very soft stage. Form the slabs by hand and use sponges, foam blocks or paper wads to provide flexible supports. These cushion the clay and will also allow movement as it dries and shrinks. Parts can be made, allowed to stiffen up and then assembled as required. If a rigid framework is used, be sure the clay is lifted free occasionally

during drying. As the clay shrinks around a tube or other object, it tightens its grip and will eventually crack if there is no allowance made for movement.

I start with soft slabs to collect details from the textured concrete wall. These are supported on foam until firm. Edges are wetted and scored, with coils added to reinforce seams. Three sides are joined together with extra foam support. Smooth seams have texture restored using bisque stamps. Tripod legs are made from extruded tubes.

Leatherhard slabs

'Leatherhard' describes clay that has dried until it has stiffness yet retains flexibility.

Soft leatherhard clay will still take impressions and bend quite easily. This is ideal for creating shapes that can be assembled into a larger whole. It is a bit like using heavy paper or card; willing to bend in one direction but resistant to multiple curves. For more complex shapes, gentle pressure by hand or judicious use of a wooden paddle will permit a gradual change in shape and overcome this resistance to some extent. A light spray of water will be helpful in softening areas designated for movement. This is best done once the larger form has been established.

Figurative work by Sally MacDonnell and Christy Keeney shows different skills in the assembly of such work. Sally models the parts from soft clay slabs while Christy assembles images from firm slab pieces which have been cut to shape.

The majority of slab work requires the putting together of several sheets of clay. It is important to make all the necessary slabs for a piece at the same time, as joins are best made between pieces of equal moisture content; and how often has the

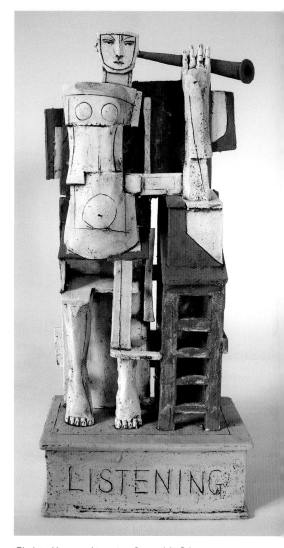

Christy Keeney, *Listening figure*, Ht: 36 cm (14¼ in.). *Photo: courtesy of the artist.*

unfortunate maker only remembered the base after the rest of the piece is near completion and rather dry. The drying and shrinkage process begins as soon as initial rolling is completed. A fresh wet slab will shrink by about 5% compared to its dry neighbour and another 5% in the firing, so it will be very prone to cracking along any seams.

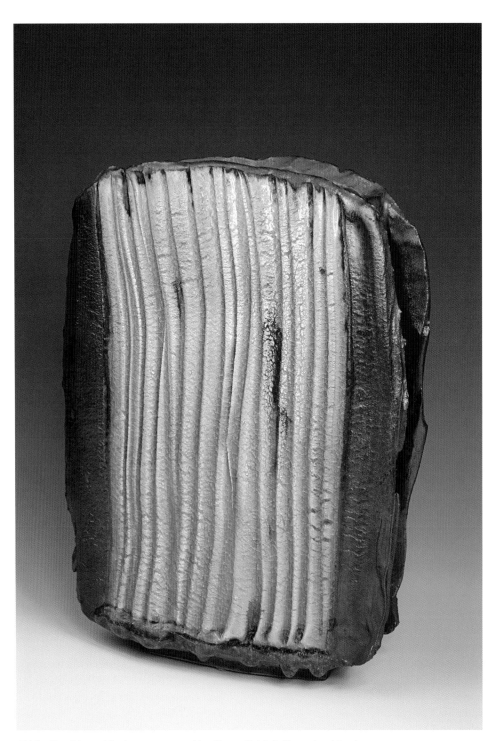

Eddie Curtis's paddled texture vase. Ht: 40 cm (16 in.). *Photo: Ian Marsh.*

I use hardboard and wood forms that provide curved shapes for the construction of vases and other work. These curves support wet slabs and create the shapes to be assembled later. For larger constructions, soft slabs are generally allowed to dry somewhat before being placed into these supports. Once leatherhard, they retain these shapes under construction. The two sides are stood up on a large base slab and joined at their edges. The base is then trimmed to size.

Even as the clay dries to a very stiff stage, it is still possible to join pieces together as long as they have similar moisture content. It is important to note, however, that slabs become more brittle as they dry out, and further bending at this stage may result in cracking.

Small surface stresses may open up dramatically in the later stages of making; when this happens during a firing, it can be quite distressing, making all your previous efforts seem wasted.

Keeping slabs workable

Once prepared, all slabs for any one piece should be maintained in a similar condition.

Plastic sheeting is a great boon for keeping clay soft and workable. However, it is useful to place paper or cloth over slabs or work in progress prior to wrapping it in plastic. If there is any air space around the clay, moisture from the clay will evaporate and condense on the plastic. The clay will continue to dry out to a surprising extent, and water droplets will often run down the plastic, sometimes streaking the work in progress. Paper or cloth will collect this water, keeping it next to the slabs, and helping to maintain a uniform softness in the clay.

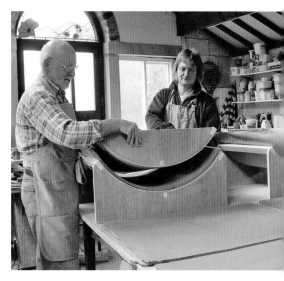

Wood forms give support to large slabs while they firm up. *Photos: Ian Marsh.*

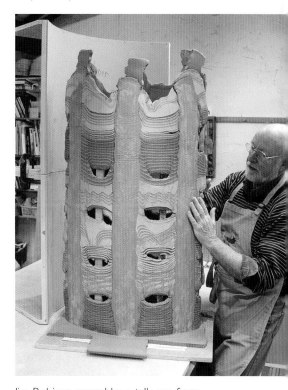

Jim Robison assembles a tall vase from leatherhard sides. Note the support form in the background.

Slabs and slab projects have a tendency to dry at their edges first, so it is often necessary to wet them. I find a spray bottle is essential for this task. Small ones are very inexpensive, while reusable spray bottles also come as a by-product of used-up cleaning materials. Judge the water content of the clay by touch and perhaps with a bit of pressure from a fingernail. For larger pieces, worked on over a period of time, I use a pump-up garden sprayer, which pressurises the water and provides a greater coverage. This is very useful if multiple sections (sculptures or panels to be assembled later) are being undertaken. Keeping work damp is necessary for you to be able to make modifications and adjustments to forms later on. Leatherhard sections may need to be stacked and refined during this process. Leatherhard clay is less brittle than dry ware, and changes can still be made while the clay retains some flexibility. With regular attention, it is possible to keep projects in a workable state for a considerable length of time.

Slabs are best made slightly larger than needed and then cut to size as the work progresses. Have your pattern to hand and think through the shape of pieces you will need at this initial stage. In fact, I only trim the slabs once the actual construction is about to begin. This means drier edges are removed so that you have softer clay to work with; the joints are much easier to make in soft clay.

Tiles

Tiles are an extension of the slab-making process itself. They may be rolled from soft clay, wire-cut from the block or pressed out from thicker pieces of clay. The most common problem with tiles is that they tend to curl upwards upon drying. Industrial tiles are usually machine-pressed or stamped out from nearly dry clay. This removes much of the moisture and thus the associated shrinkage that can cause so many problems. Hand-rolled tiles are by nature wet and need to be handled with care. If possible, turn them over occasionally to help them dry uniformly on both sides. Warping can be reduced somewhat by cutting grooves into the back, as this permits air to circulate and encourages even drying; it will also aid adhesive attachment to walls. Another method involves placing the tiles on wood slats, which also lets air underneath the clay. Alternatively, place them on absorbent boards while keeping them covered. Tiles may be weighted down during drying, although too much weight will cause them to crack in the stress of shrinking. Chris Jenkins espouses the simple approach of stacking leatherhard tiles upon each other in groups of six or so, placing paper between each one, covering them with a board and allowing them to dry out slowly. Much depends on the size of the tile, any relief texture or surface decoration that might be present, and how much space you have to dry things out.

Drying slabs for assembly

Allow your slabs to dry out to the desired stiffness for the scale and complexity of the work you have in mind. Slabs are usually rolled out on cloth or another absorbent surface, so the drying actually begins at the point of making. To continue this process, place or turn

over the slab onto another surface. I use pre-cut pieces of hardboard (Masonite) with a slightly textured surface. This texture reduces any tendency for the clay to stick, allowing it to be lifted free again when so desired.

Other absorbent surfaces include unpainted plywood, chipboard or fibre-boards. Cement boards or plaster bats may also be used. If available surfaces are non-absorbent (tabletops, or painted or melamine shelving boards, for example), then several layers of newspaper, brown wrapping paper or cardboard will do the job.

Be aware of the environment you are working in, including such factors as room temperature, humidity, air movements (draughts) and heat sources. Even sunlight through a window may cause unexpectedly rapid drying conditions, leading to uneven shrinkage, warping and even cracking. Conversely, just the opposite of projected drying may occur when, for example, the heat goes off in the evening and condensation starts to build up. Moisture collecting under plastic wrapping may cause softening of the clay.

My studio in Yorkshire remains cool and damp once the heat is switched off in the evening, so gentle overnight drying of slabs generally works quite well. However, the early morning sun through the window may catch one slab and render it very hard and unfit for purpose. Controlled drying means covering the slabs with paper and plastic until you are there to keep an eye on things. Absorbent boards and paper, even under plastic, will remove a considerable amount of water overnight.

It is possible to rapidly dry items with electric hairdryers, paint strippers or gas torches. I sometimes use heat sources to rapidly dry painted slips on slab surfaces. Small pieces can be handled when firmed up a bit; however, it is difficult to achieve or to judge even moisture content in a larger slab, as only its surface is immediately affected. Pieces can also rapidly become too dry for strong joints. It is possible, of course, to re-wet slabs, even whole projects, but it is so much easier to carry on with a project in stages that occur naturally as the clay gradually dries out.

Cutting the clay

The potter's knife will be the first choice for most of us. Sharp-pointed and with a comfortable handle, its universal appeal is easy to understand. When clay is laid upon cloth, it is important to take care not to cut the underlying cloth. In fact, you need only to score the slab deeply to separate the two pieces. Once leatherhard, slabs may be lightly scored and snapped in two. Simply bend the clay away from the cut surface.

The harp, with a wire stretched between the ends of a hoop, is useful when cutting blocks of clay or trimming slabs where there is access to both sides of the clay. A small harp can be adapted from a cheese cutter: simply remove the roller that adjusts the slice thickness to obtain a robust inexpensive tool.

There will always be a tendency for the clay to break off near the end of any cut. Avoid this by pressing your hand against the clay as you near the end, or turn the knife around and cut from both ends of the slab into the middle.

When making a mural for our bathroom, I framed a large single slab with an extrusion and painted it with

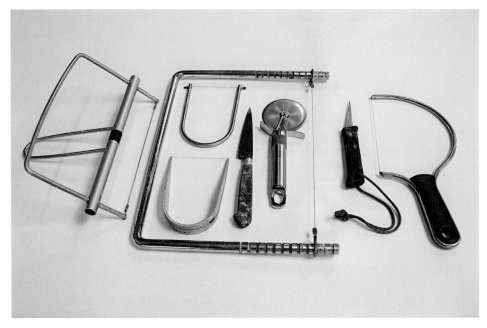

A selection of cutting tools.

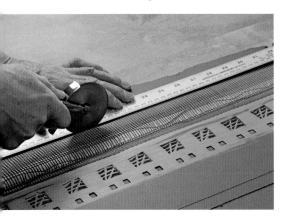

A pizza cutter provides smooth trimming.

slips. As it was cut into tiles while still quite soft, there was a tendency for the corners to be stretched out of shape by the knife. The round wheel of a pizza cutter offered a simple solution. This cut the slab by pressing down against its supporting table, thus removing any stress or distortion at the edges and corners.

Joining the clay

When very wet and soft, the clay seams may be simply pressed together and they will stay put. If done firmly, this may be sufficient. However, drying and the resultant shrinkage often pull seams apart. It is usual to prepare slip made from the clay body and a little water to use as glue between pieces of clay. Importantly, all pieces to be joined should have identical or at least similar moisture content. Carefully scoring the pieces gives additional purchase for the slip to bind the joint together. 'Stitching' the pieces together by pressing firmly into the clay with a pointed modelling tool, dragging the clay from one slab to another to join them will help. Finally, adding a coil of clay for reinforcement generally ensures an adequate bond. (It is worth adding a note about drying at this point: rapid and uneven drying increases the strain on joints, so the more gentle and uniform the process, the less likely you are to see cracks develop.)

Water, brushed along the edges of pieces to be attached, will aid the joining process. It softens the clay to be joined and helps create a transition from firm slab to soft seam. If it is used in conjunction with a toothbrush and the clay is scratched with pointed tools, the result will be soft rough surfaces that can be easily pressed together. In fact, the use of water alone when scrubbed in this way creates its own slip from the clay to be joined. This in turn acts as the necessary glue to hold the work together.

Keith Rice-Jones goes a stage further, with small additions of sodium silicate and soda ash to the liquid. This creates what he calls 'magic water' (3 teaspoons of sodium silicate and 1½ teaspoons of soda ash added to a gallon of water), which has properties that soften the clay rapidly and create a layer of deflocculated slip along the edges to be joined. It is definitely worth a try.

Corners can be tricky. To keep them crisp and straight, support the slabs during the process. A couple of flat sticks, held on either side of the seam, will prevent distortion when joining the two pieces of clay. I found a right angle of cardboard packaging helpful. 'Stitching' can again be done at this point, and you can also add a reinforcement coil on the inside corner. I believe it is always nice to see a neat seam, so use a metal or plastic kidney shape to go over the joint to smooth the coil into the side walls and remove any excess clay.

RIGHT, TOP Keith Rice-Jones uses wood and paper supports to construct his large sculpture *Birth of the Rockies*. Ht: 90 cm (36 in.). *Photos: courtesy of the artist.*

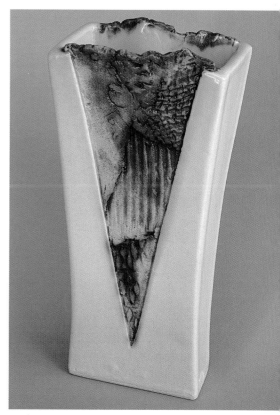

RIGHT Keith Rice Jones's contrasting inset slab in this smaller finished work. Ht: 40 cm (16 in.).

Mitre joints

Mitre joints will give added strength and precision compared to the normal butt joint. When cut on 45-degree angles, the slabs will have nearly 50% more surface area across the joint. It will even be an advantage to cut flat slabs this way to create an area of overlap when adding a bit to an existing structure or another slab.

Several methods are available for cutting the angles precisely. A knife held against a bevelled piece of wood will do the job. Specific tools have also been designed for this purpose. Most slab-builders use a piece of wire for the cutting edge, as this has a minimal drag on the clay and is therefore easy to use provided the clay is not too hard.

When pushed together as a butt joint, the seam leaves an end slab on view. Mitres avoid the end of a cut slab being visible at joints. Patterns, textures or painted areas can be made into continuous surfaces around corners using this method. If you are careful, all 'stitching' and reinforcement coils can be done on the inside of the piece without disturbing the outer surface. A piece of newspaper or plastic film wrapped around the outside will keep you from smudging slips or textures. Paper will absorb water from the seam and leave very little touching up to do later.

There are exceptions to most rules, and such is the case with paper (or fibre) clay. Fibres found in paper, plants and numerous textiles add considerable strength to unfired clay. As a result this material has found many enthusiastic supporters in the potting community. Reinforcement threads are distributed through the body and help bind the particles together. This offers the maker

A knife held at an angle to provide the correct angle for joining the sides together.

Angle-cutting tools for improved joints.

A wire cutter provides a 45-degree angle joint. *Photos: Ian Marsh.*

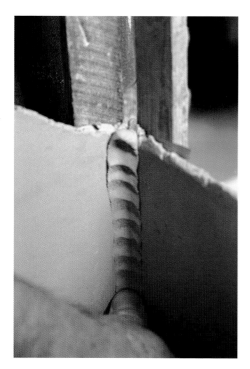

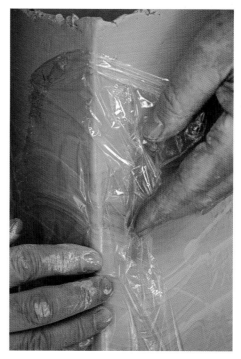

A coil added to reinforce the joint, supported by wood slats. *Photos: Ian Marsh.*

Film or paper will protect patterns while the seams are pressed together.

several distinct advantages, foremost of which is a resistance to cracking. Some makers use rigid wire armatures to support the modelling of quite fantastic shapes, and most pieces may be rapidly dried without fear. If the wire is heat-tolerant, it may even be fired in place.

Another advantage is ease of manipulation and construction. Joints can be made between slabs of differing moisture content, and the usual drying rules do not seem to apply. Even bone-dry slabs may be joined together with a bit of water and fibre-clay slip. Moreover, repairs or alterations can be made at almost any stage. Broken pieces can be repaired even when dry. On occasion I have found fibre clay useful for repairing

cracks in other pieces too. It does open up great possibilities.

There are some downsides, of course. Prepared paper clays are relatively expensive, and making your own is labour-intensive, requiring, as it does, making the clay into slip before adding the fibres, mixing, and then drying out the mixture before use.

Plant cellulose does generate a slippery feel, which personally I find somewhat off-putting. The clay may have a tendency to smell if kept in storage for an extended period. However, synthetic fibres don't suffer this problem, and small additions of liquid Milton steriliser or bleach will retard any mould growth.

Jim Turner's work shows the freedom of surface possibilities in paper clay. Ht: (foreground piece) 20 cm (8 in.), (background piece) 50 cm (24 in.).

Night Sentinel by Jed Schlegel uses strong textures and contrasting colours. Ht: 90 cm (36 in.). *Photo: courtesy of the artist.*

Martin McWilliam's jar and bowl emphasise composition and space between refined forms. Ht: approx. 50 cm (20 in.). *Photo: courtesy of the artist.*

James Hake's dish has bold feet and subtle edging. Dia: 35 cm (14 in.). *Photo: courtesy of the artist.*

Two-Faced Head by Alasdair MacDonell demonstrates the effect of multiple textures. Ht: 30 cm (12 in.). *Photo: courtesy of the artist.*

Chapter 4

Textures, Impressions, Mark-making, Colour

Soft clay is very receptive to textures, impressions and mark-making. Overall texture will be part of the slab-making process itself if the rolling out takes place on cloth or textured paper. Alternatively, it might be an additional application after the slab is made, the chosen texture being laid on the clay and simply pressed down with a rolling pin. John Wheeldon uses textured wallpaper for the slab rims of his lustre-decorated and smoked raku dishes.

Bernard Irwin's slab pots are created by the straightforward rolling method of inlay. As the clay is rolled out, coloured clay and porcelain is added until the size and shape of the desired slab is obtained. Subtlety of surface is achieved through the textural effects afforded by the combination of clays and colouring oxides. His aim is to 'maintain freshness through lightness of touch'. This approach is continued by once-firing (there is no bisque firing) the pieces to stoneware temperature in an electric kiln.

Slab impressions

One technique I use to texture larger slabs is to roll the clay onto a damp cloth. When the soft slab is stuck to this, it will act as a support. Carry both cloth and clay to an interesting surface (stone,

Bernard Irwin uses inlaid clay and porcelain for colour on this unglazed vessel. Ht: 41 cm (16 in.).
Photo: courtesy of the artist.

John Wheeldon uses wallpaper texture and sponge-printed lustres on his raku dishes. W: 30 cm (12 in.). *Photo: courtesy of the artist.*

brick or concrete-block wall, cracked pavements, tree bark, etc.) and literally throw the slab against it. If done with some force, the texture left behind is quite detailed. Carefully peel away the slab from the wall or other chosen surface.

One commissioned wall piece I did was for a housing company in Liverpool. To add a touch of reality to the project, clay slabs were used to take impressions of the walls of Liverpool Docks and the commemorative pavements in front of the iconic Liver Buildings. These slabs could have been used directly in the work, but I chose to bisque-fire them and treat them as moulds. This revealed the stone relief to good effect.

It is important that the surface chosen is absorbent and dry or the clay may stick and refuse to come off, staying firmly embedded in the texture. If you're unsure about a surface, test a small piece first. To reduce the risk of sticking, dry out the slab surface a bit prior to the throw; this will make it less likely to stick fast. To do this, leave the slab in the sun for a few moments, apply heat – using a hairdryer, paint stripper or torch – or simply dust the surface with powdered clay. There may be some residue left when the slab is removed, so consider your choice of surface before you take any action.

A cleaner alternative is to cover the slab with a layer of cling film. This will

ensure easy removal and leave no mess to clear up afterwards. However, this method loses some crispness, as film tends to soften the edges of textures. The cloth backing lends support to the whole enterprise and may be removed after the textured impression is taken. Smaller textured areas do not require this cloth support, as a small slab may be carried by hand and slapped onto the chosen surface.

Mark-making tools

At this stage you can use hands alone or a variety of tools. Test areas with the fingers drawing, pushing or pinching the clay. Single marks may look unexciting, but repeated shapes become much stronger. Patterned rollers and stamps are available from printmaking suppliers. Wooden rollers, textured surfaces and patterned tools will be found at ceramic specialists too. These tools allow the rapid repetition of marks across a surface. Interesting items can be found among a variety of other sources. Some of my favourites came from the building-materials or painting and decorating firms who make Artex wall and ceiling coatings (a textured coating, similar to plaster). A bit like a thick paint, or thin plaster, this stuff can be combed or patterned in a variety of ways. The textured rubber rollers made for this are ideal for making impressions in soft clay.

Don't overlook the possibilities found in hardware and kitchen shops either. The rolling pin is an obvious item, but pizza and pasta cutters offer sharp cutting edges, and there is also a serrated roller for creating latticework pastry piecrusts. A piecrust mark or two created the suggestion of wind and rain falling in my *Yorkshire Weather* series.

Combs provide a unique way of creating parallel lines on the clay itself or drawing through layers of painted slip. Combed spreaders for tile adhesive,

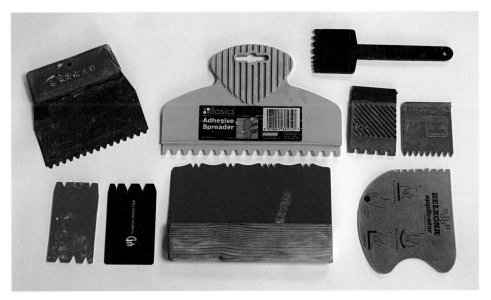

Combs can be cut from plastic cards or bought from a variety of sources. Tile and decorator's shops offer many choices. *Photo: Ian Marsh.*

toothed scrapers, the long tines of an onion holder, barber's tools or even an old nit comb will make lovely delicate lines. Specific potter's tools are also available, but personal ones can easily be made in wood, metal or plastic. Save money twice by taking a pair of scissors to a store or credit card. Cut notches out of one side and draw it across your slab.

Multiple lines increase a sense of organisation. They also suggest depth to the surface as large marks advance and small lines recede. Try a variety of line width and spacing. Remember that, as in drawing, the longer a line, the stronger it becomes, and that the eye will find interest in broken lines, connecting them into shapes with an overall pattern.

Stretching

One of the magical properties of clay is its ability to stretch and change shape under pressure. This is easy to see when on the potter's wheel, as the hands coax a hollow mass into an elegant shape, but most of us are less aware of this potential when working with slabs.

Thick slabs, cut from a block of clay, may be stretched into thin and surprisingly uniform sheets. To do this, the slab is picked up by one end, thrown from side to side and dropped upon a board or unvarnished wood table. Friction from contact with the table increases the slab's length through sideways motion. When doing this, it is important to let the trailing edge contact the table first, while you continue the directional motion with the hands.

RIGHT A tile detail of a duck drawing on a school sculpture. *Photos: Ian Marsh.*

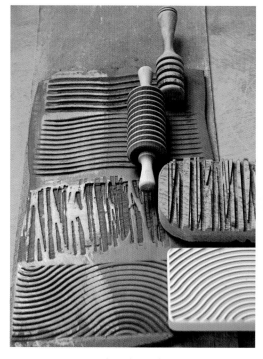

ABOVE AND OVERLEAF A variety of impressions may be created using stamps, rollers and paddles. Aside from pottery suppliers, try kitchen and decorator's shops for unusual items. These pictures include a honey twirler, a pastry roller and a meat tenderiser. The dimpled impression (*bottom picture, far right*) is from a back massager. Note that the impression is made more visible by a brush of contrasting slip laid over the top.

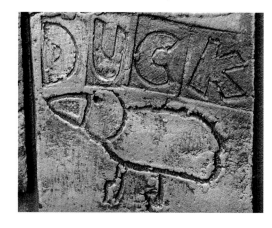

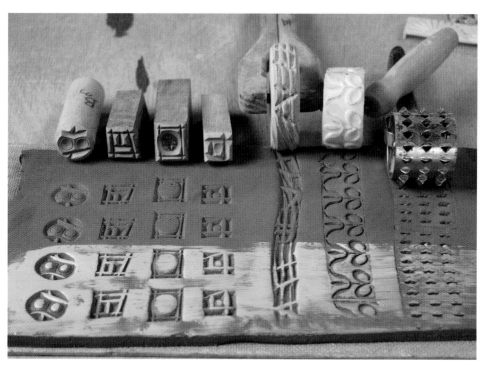

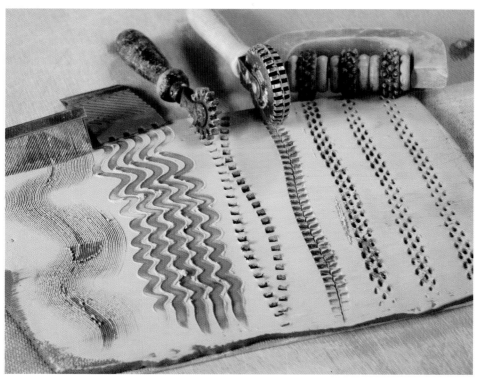

Otherwise it bunches up in a rather interesting fashion – creating more of a lump than a slab.

Any impressions, drawings, marks or textures made in clay develop an irregular, spontaneous quality when stretched in this fashion. An example of this may be seen in the sculpture done with young schoolchildren (see p.56). They drew creatures found in the nearby nature reserve on clay tiles. When stretched slightly, the drawings' linear qualities became uneven, slightly abstract, and I believe this variety makes them all the more interesting.

Eddie Curtis creates a fascinating surface by stretching thick slabs. He first dries out one side by rolling it into powdered clay. This side may also be textured before stretching. The slab is then tossed from side to side until Eddie is satisfied with its surface and reduced thickness. These slabs then become the sides and other elements of his dramatic handbuilt pots.

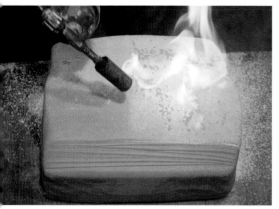

ABOVE, TOP TO BOTTOM
Eddie Curtis rolling powdered clay into the surface.

Rapid drying of the surface with a gas torch.

Stretching the soft slab causes dry surface cracks.

Eddie Curtis making a slabbed jar. Uniform thickness is obtained by wire-cutting the inverted slab, this preserves the dramatic textured surface. *Photos: courtesy of the artist.*

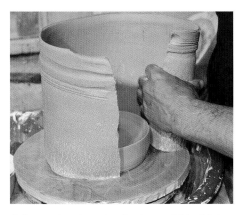

A thrown bowl creates the base of this slab jar.

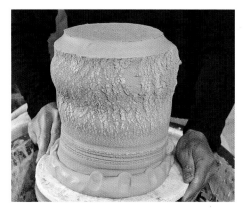

Clever use of a soft coil applied to a leather-hard rim allows the pot to be inverted on the wheel for trimming.

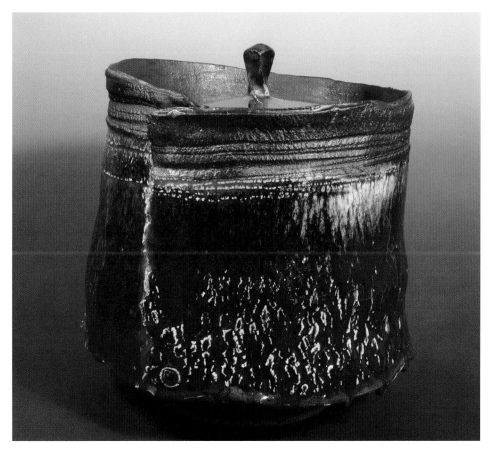

Eddie Curtis uses contrasting copper effects for black rim and red reduction glaze over his textured jar. Ht: 30 cm (12 in.). *Photo: courtesy of the artist.*

Brendan Hesmondhalgh starts animated constructions by pressing out his slabs underfoot. *Photos: Ian Marsh.*

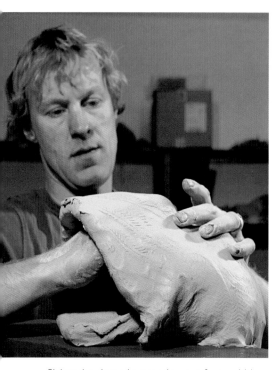

Slabs take shape by pressing out from within.

Brendan Hesmondhalgh first constructs the basic shapes of his birds and animals from thick slabs pressed out underfoot in plastic bin liners. These simple shapes are then stretched from the inside, giving them increased volume and convincing forms. Surface textures, scored lines and other marks are given a special freshness as his hand works from the interior, pushing outwards while leaving the surface largely untouched. Coils and small details are added later.

Slabs can be stretched and re-stretched on the slab roller. I enjoy the rather spontaneous nature of this exercise. Edges are the first place to show cracks when a slab is rolled. And when a slab is doubled over and rolled again, these edges break up dramatically.

Slip of a contrasting colour can be applied to the edge prior to rolling for clear definition of lines and shapes along this overlapped edge.

Torn openings can also be induced in the middle of sheets of clay by adding multiple layers of clay. Strips placed on each edge of the main slab build up a thickness that will cause the centre to stretch as it passes through the rollers again. This second rolling brings the multiple layers back to an original thickness and in doing so adds greatly to their length. When pushed beyond its ability to stay intact, the result is torn openings in the main slab. Some control over the location of these holes can be obtained by scoring the surface with a knife. Cuts weaken the slab, so that it will tear at these points first when under the pressure of rolling. Note that the stretching occurs mainly in the direction of rolling, so score at right angles to this flow for best results.

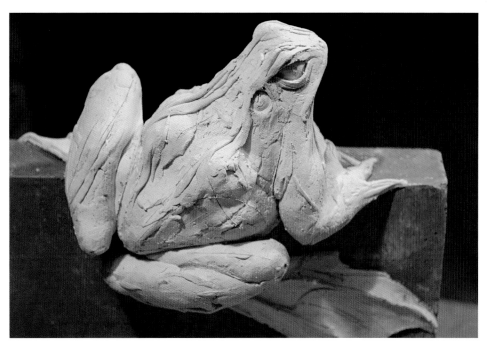

Brendan Hesmondhalgh's bisque-fired frog shows coil additions to the surface. W: approx. 30 cm (12 in.). *Photos: Ian Marsh.*

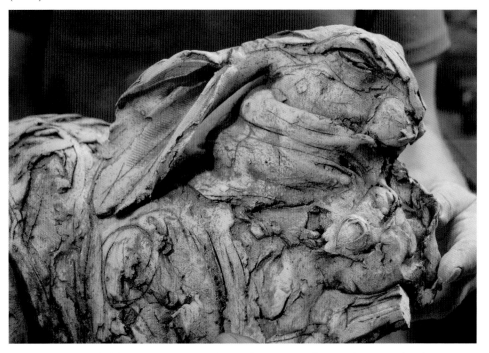

Brendan Hesmondhalgh uses stains and oxide washes over cut lines and stretched surfaces.

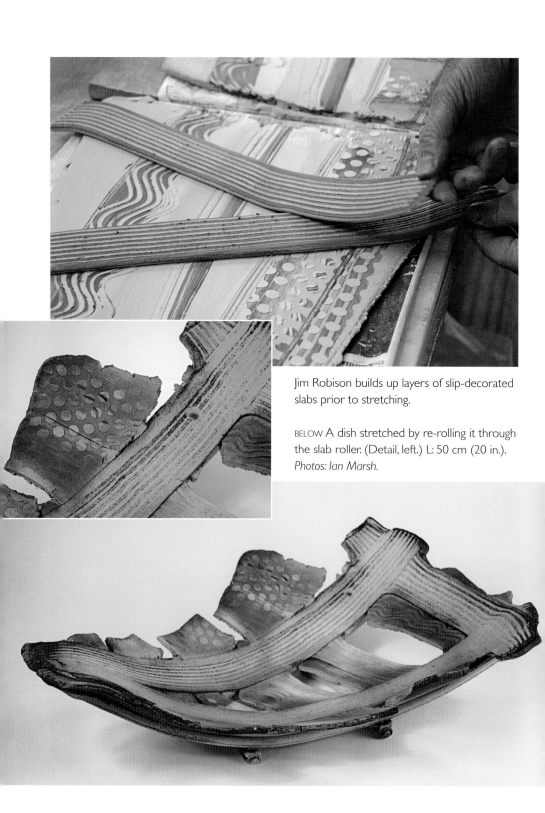

Jim Robison builds up layers of slip-decorated slabs prior to stretching.

BELOW A dish stretched by re-rolling it through the slab roller. (Detail, left.) L: 50 cm (20 in.). *Photos: Ian Marsh.*

Colour

Colour can be considered in three stages during the making, decorating and glazing. Colour can be introduced within the clay, in slips and oxides applied to the clay, and in glazes.

Clay

First and perhaps foremost is the clay body itself. This is the underlying basis of all firing results, and influences everything on top. A light body will promote brighter colours while a darker one (usually with naturally occurring iron content) tones down lighter shades. Glaze coverings might be compared to watercolour painting as most are transparent or translucent. Painting on white paper will appear very different to brushstrokes over manila or brown wrapping paper.

Whiteness can be achieved through bodies containing light ball clays and china clays. In terms of glazing, these bodies require smaller amounts of expensive glaze opacifiers such as tin or zircon to cover them effectively. Opacifiers are used in glaze to give a white base to show off the colour of the glaze. Porcelains may be chosen for unglazed whiteness. When burnished or rubbed down they will have a satin translucent quality.

Jude Jelfs uses slab vessels as a canvas for personal expression, with a combination of coloured slips, underglaze and oils on her earthenware pieces. Ht: approx. 25 cm (10 in.). *Photo: courtesy of the artist.*

Craig Underhill uses a combination of slips and glazes for abstract images. Ht: approx. 45 cm (18 in.).
Photo: courtesy of the artist.

Dennis Farrell's *Abandoned Vessel* uses a very painterly approach in the application of slip and glaze. Ht: approx. 60 cm (24 in.). *Photo: courtesy of the artist.*

Colours mixed into porcelain or other clay may be used to create beautiful agateware. Agateware is usually left unglazed, although it may be sanded and polished after firing. Transparent glaze may also enhance the surface. Earthy tones are generally sought for sculptural forms, so iron-bearing clays are quite appropriate. In fuel-burning kilns, a reduction atmosphere will encourage darker tones. Iron specks can appear on the surface and bleed through the glaze. Colour may be added to the clay for greater intensity,

White slip brushed over a darker body brings out texture.

Coloured slip brushed over an impressed cloth stencil.

and some prepared clays, such as 'lava fleck', include granular material which attempts to duplicate this reduction effect in electric kilns. Experience teaches us to choose the clay body based upon the final results desired.

Slips and oxides

The second stage is the application of colour to the clay body in the form of slips and oxides. Slips are clay-based, fairly opaque (although I consider them to be translucent when applied thinly or fired at stoneware temperatures), and stay put when applied to the clay body itself. A simple use of white slip, brushed over a dark body, will allow textures to emerge and strong patterns to be created. A standard mix is equal parts of white ball clay and kaolin or china clay. With shrinkage similar to the body, they should be applied when the clay is wet or leatherhard. (Bisque-ware slips can be mixed that contain more glaze-like characteristics, with some of the clay being replaced by feldspar or frits. These have less shrinkage and fuse better to the body during firing.)

Colours in the form of stains or oxides can be added to the slip. Amounts between 2 and 10% should be enough, depending on the recipe. Although considerably more colour is required in an opaque clay slip than a transparent glaze, it will still be less expensive than colouring the entire clay body itself. For slightly brighter effects, I use a porcelain body for coloured slips.

Brushed on, sometimes over textures, or stencils, fixed patterns will show up clearly under subsequent glaze application. For dark colours, a red clay slip makes a good starting point as it

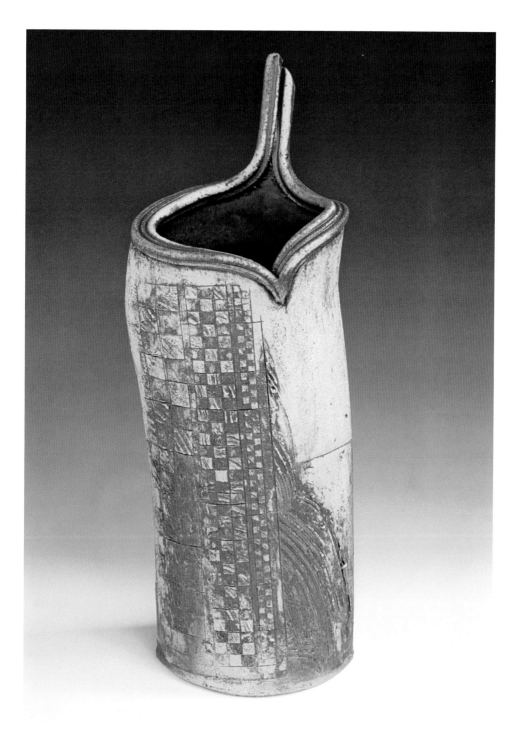

A manganese dioxide and water wash emphasises the textured surface of Jim Robison's pot.
Ht: 40 cm (16 in.). *Photo: Ian Marsh.*

already contains significant amounts of iron oxide. Both of these clays, the porcelain and the red clay slip, will fuse to the surface at high (stoneware) temperatures, and might in effect be called slip glazes, requiring little subsequent glaze application.

Colourant oxides may be mixed with water or a bit of glaze and applied to the body. A favourite technique is to brush a wash of iron and manganese over the surface of a bisque pot; copper oxide or carbonate is also useful in this context. These may then be sponged off to leave dark shaded areas with emphasised textures. For health and safely reasons, a dust mask and rubber gloves are recommended during this procedure.

Glaze

Thirdly, we are able to apply a range of colour and surface options through glazing.

This subject is too vast to be studied in depth in this volume but it is important to point out the most obvious glaze considerations: surface, opacity and colour.

Surface

Glazes with matt, satin or gloss characteristics vary the light reflections from the surface of the piece. I believe that textures benefit from matt glazes (less shine lets you see the form, while rough surfaces will glitter under a glossy coating). Satin glazes lie somewhere between matt and shiny. They are smooth but not glossy and will be described as 'soft'. These will invite a touch and a rather warm response. Glazes that shine are clear and bright and described as 'hard'. The choice of glaze affects literally the entire feel of the piece in question.

Opacity

Opacity will alter the impact of the clay body and subsequent slip applications.

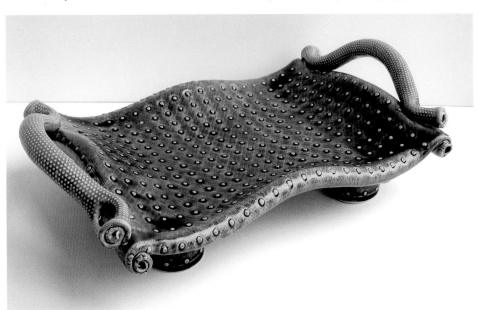

Roger Lewis's *Dot 2 Dish* uses high-gloss glazes to emphasise textured surfaces. L: approx. 20 cm (16 in.). *Photo: courtesy of the artist.*

This can be increased through glaze modifications (usually tin, zircon and titanium, or significant additions of opaque clay content.) Some glaze ingredients will also form crystalline structures that develop during firing and cooling. These reduce transparency, producing satin and matt surfaces. Thickness of application is also an important consideration, as heavier coatings will have a great effect on the visibility of the body beneath.

Regina Heinz uses careful masking, multiple applications and several firings to build up layers of colour. A dark lithium glaze is brushed on and wiped off to emphasise incised linear elements of the bisque-fired piece. This is followed by

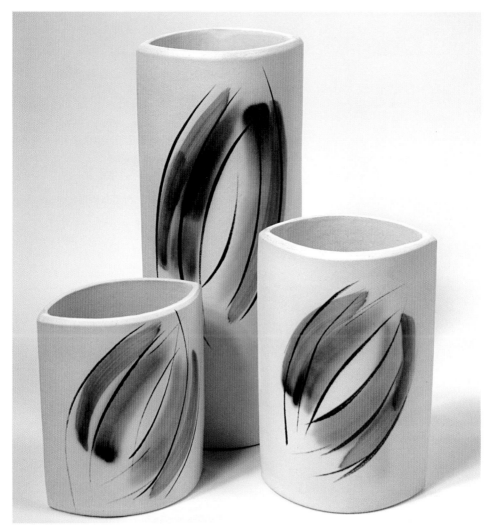

Ian Marsh uses slip coloured by copper carbonate and blue stain under this tin white glaze. Manganese brushstrokes are then added. Ht: 23–50 cm (9–20 in.). *Photo: courtesy of the artist.*

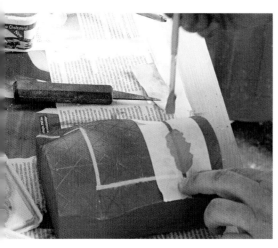

Regina Heinz applies yellow and blue biscuit slip as part of the design.

Regina Heinz sculpture uses multiple colour applications to create geometric patterns. Ht: 16 cm (6 in.). *Photo: Alfred Petri.*

a fired-on application of red iron oxide. Lines are masked out and painted on in yellow and blue bisque slip as part of the design. Then a second lithium glaze is brushed on and the piece re-fired. After the second firing, a wash of blue pigment is applied to the lithium glaze to subsequent masked-out areas and the piece is fired for a third time. These glazes are fired to earthenware temperatures 1035°C (1895°F). Effects vary greatly with temperature variations.

I apply glazes more simply with a spray gun, as it offers the choice of thin coats or thick multiple layers. This allows body texture to show in places, keeping slip colours and brushstrokes clearly visible. Thicker areas create a gradual transition in opacity and make changes to the surface quality of the glaze.

Colour, light and shade

Colour invites its own response. Often described as 'cool' or 'warm', with references to the world around us, it describes both mood and objects. Potters will sometimes joke that when a piece fails to sell, you should re-glaze it blue for an improved response. This flippant remark aside, as a student I was encouraged to consider first the areas of light and dark, and then add some colour. This creates the structure of a composition through tones and shapes before building in the colour response. I've developed a sequence of application that begins with the darker blue/black- or yellow/ochre-coloured glazes being sprayed over textures and edges, then upwards into shadowed areas to increase the effects of light and shade upon the form. These dark colours are sponged or brushed off the highlight areas or

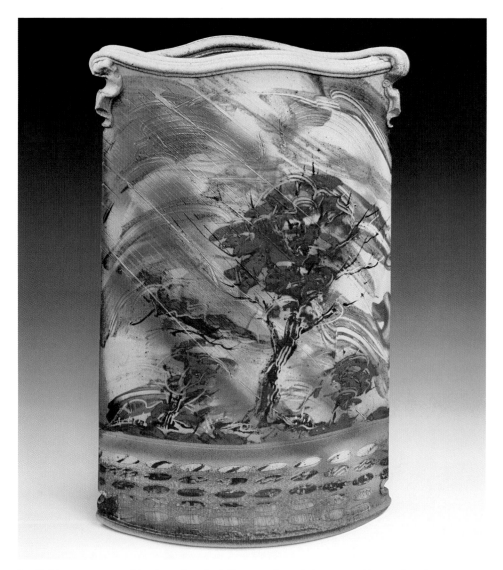

Jim Robison uses a combination of applied slips, stencils and glazes to achieve painterly landscapes. Ht: 45 cm (18 in.). *Photo: Ian Marsh.*

textured surfaces, leaving shades in the recesses and in particular shapes in the background.

I emphasise these tones in the choices of clay and slip before any application of colour in glazes. Lighter glazes, tin white or a pale matt ash mixture are applied over these tones, emphasising the now unglazed areas (often white slip) that have been exposed. Spraying downwards with pale colours will re-emphasise factors of light and shade on the form. Several glazes may be blended and overlapped to create very painterly effects.

Firing temperatures and atmospheric conditions in the kiln will also play their

part. Low-temperature earthenware glazes tend to stand on the surface of the ware, while high-temperature stoneware glazes eat into the clay and begin to merge with the body itself. In general, there are more colour options at low temperatures. Earthenware colours are brighter and more intense. Many bright colours become fugitive at high temperatures, although the range of successful reds and yellows has increased in recent years. Paul Andrew Wandless uses a variety of low-temperature underglazes and glazes. He prints directly on slabs using lino and silkscreen techniques prior to construction, bisque-firing and glazing.

Stoneware glazes are usually more muted and subtle, while also providing the advantages of increased strength and being frostproof. Fuel-fired kilns (in contrast to electric ones) may provide atmospheric changes (reductions in oxygen) that dramatically modify the colourant oxides. As a flame with insufficient oxygen is forced to seek it from clay and glaze within the kiln, copper may change from green to red, and iron may go from brown to green.

In the end it is a combination of experience, effort and luck that brings about the successful merger of body, slip and glaze into a unified surface.

Jim Robison's dish demonstrates the tin pink which develops in reduction firings, when copper is present. Wood grained effect is red clay slip under thin glaze. L: 36 cm (14 in.). *Photo: Ian Marsh.*

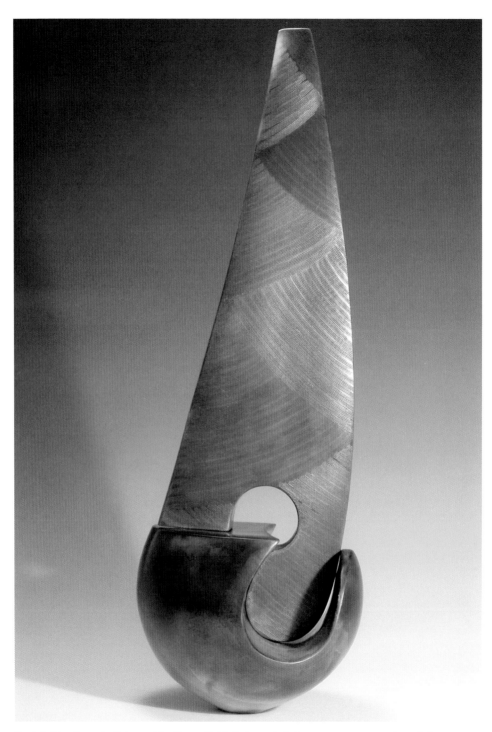

Dark Sail by Antonia Salmon. Ht: 42 cm (16 in.). Antonia Salmon creates examples of elegant simplicity in balanced and textured pieces. *Photo: courtesy of the artist.*

Chapter 5

The Importance of Detail

The outstanding potter David Lloyd-Jones once said to me, 'Have a strong rim and strong foot, and the rest of the pot will take care of itself.'

Without wishing to minimise the importance of form, it has to be said that he did have a point. The overall shape of the pot is often defined by how it starts out and how it ends. The way that sides start out from the base determines the visual weight and balance of the entire piece. A rounding of edges, an inward curvature at the point of contact, brings with it light, air and a reduction in apparent weight. Coil builders will tell

you that the first few rounds dictate the entire form and scale of the piece to be developed. The initial size of the base, its symmetry and the projected angle upward and outwards all suggest the directions in which the piece will grow. Throwing brings with it the spiral creation of form through pressure from the hands. Starting from the inside, at the very centre of the base, this form also grows outwards and upwards from there. A bowl with a small base or foot ring will appear to have what is often called 'lift'. It seems to float above the base. Some trimming or turning may be necessary

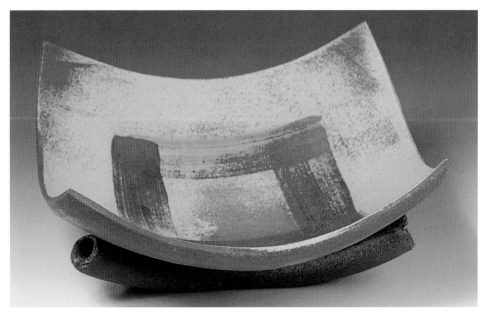

Ian Marsh elevates this simple slab dish, using extruded tubes as feet. 30 cm (12 in.) square. *Photo: courtesy of the artist.*

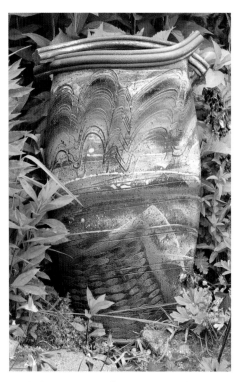

Jim Robison uses profiled extrusions for the rim of this garden vase. Ht: 76 cm (30 in.). *Photo: courtesy of the artist.*

at leatherhard stage to create this form. Anyone working with slabs will also need to consider how they will approach this area. Which profile will most benefit the form? Which detail might enhance the seam that joins the side to the base? Which foot might seem to lift and support the mass above it?

At the other end is the lip or rim of a vessel. The visual conclusion of a piece takes place here, and the importance of this detail can't be overestimated. David Lloyd-Jones emphasised a certain 'generosity' in a rim. A substantial fullness suggests confidence and security, with its visual weight suggesting skill and certainty. On the other hand, thin sharp edges can look mean and strained, and make the pot under it feel heavier when handled. Good examples of this difference can be seen in the early thrown pots made by beginners. Typically, these have a heavy base and thick side walls pulled up with considerable effort to their maximum height. In such inexperienced hands, the clay tends to run out and the upper section is tapered to a thin uneven lip. This struggle is visual as well as physical, and these pieces offer disappointment to the beholder. This visual impression is reinforced when the pot is picked up, to reveal an uneven weight and a lack of balance.

Joining the side to the base

Slab ware is notable for its assembly process. Vertical sides may join the base at right angles, so joints need to be carefully made, reinforced with coils and profiled to fit the shape of the piece. After the form has been scraped with a kidney or other tool, a bevel cut along the bottom will clean away sharp edges and soften abrupt changes in direction. A small undercut in this way creates a shadow that frames the piece and carries the eye around the work. This also reduces the visual weight.

An alternative to a clean blending of joints is to make them into a feature by adding an extra coil to the seam and shaping it into a profile. This can be done by hand with a bit of chamois leather held between the thumb and forefinger. Wet the coil and go over it several times to smooth it into shape. For more precision, a simple tool can be made from an old credit or phone card. Using a drill, file or touch the credit card with a small Dremel grindstone to create a round profile that can be pulled along the coil to give a very neat finish.

Rim

The upper edge of the work is a line that defines the shape it contains. A clean-cut edge may suffice; it offers a matter-of-fact statement which shows clear intent. However, you might prefer a torn or more natural ending to the form. There are lots of ways to do this. The slab-rolling process creates an irregular edge, which might be left as it is.

If a knife is used but only cuts part-way through the slab then an edge that is both smooth and rough will be the result. Rims or lips may be profiled

The base joint is refined by an angle-cut profile.

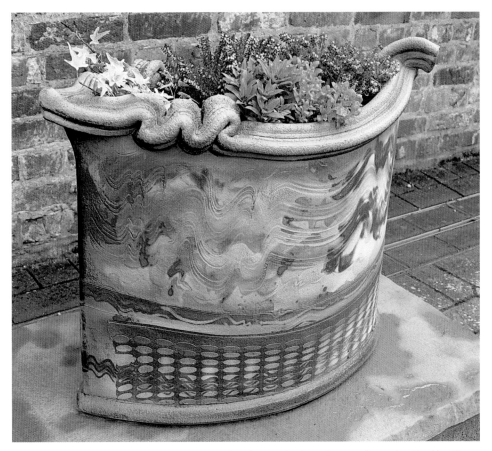

Jim Robison's large planter uses a bold extrusion for emphasis and strength on the rim. Ht: 60 cm (24 in.). *Photo: Ian Marsh.*

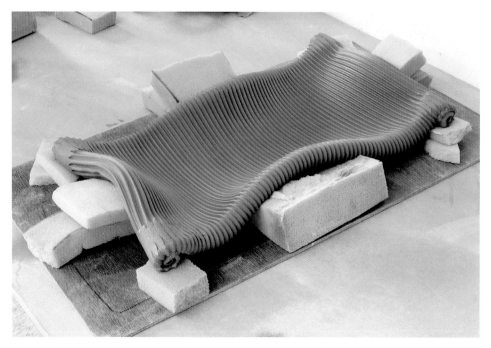

Roger Lewis's rolled edges give a completed feel to this dish. Foam pieces support the slab during drying. *Photos: courtesy of the artist.*

Roger Lewis's textured clay tubes make interesting feet and handles.

Attach feet and handles with care. Note the pin, used to pierce the handle and remove the possibility of having trapped air and steam during firing.

by hand or shaped with a kidney or other tool. A lip or rim can be tapered inwards, leading the eye into the interior of the piece, or bevelled outwards from its inner skin. Additional clay can be attached to thicken the lip and make it strong and chunky, or shaved off to create a thin edge and a more delicate impression. The important thing is to consider its relationship to the piece, and the overall effect created. Roger Lewis creates his edges by rolling the textured slab, which makes for an interesting visual movement across the work.

Another solution is to extrude this detail. Extrusions are commonly used for making clean handles. This technique leads to precision and, on a rim, adds a framing element to both the interior and exterior of the piece. A simple die can be made by drilling a group of holes through a bit of wood, metal or plastic. Holes force the clay into a ribbed profile. Each hole makes a coil, and a combination of several joined together will create ridges and grooves that reinforce the linear impression. These ribs may go up and over the lip to create a right angle at the back that will rest on the upper edge of a slab. This will aid attachment to the slab. If a small slot or groove is designed into this extrusion, it can be placed directly over the edge of a slab for a very tidy and secure fit.

Like soft coils, extrusions will bend, fold and curve in an elaborate fashion if so desired. The ends may be extended beyond the work and transformed into handles or decorative details. This wonderful organic quality makes me think of the artist Gaudí, his use of fluid linear elements to enhance his art and architecture.

Paul Young uses carefully made feet and finials to finish off this lidded box. Ht: 30 cm (12 in.).

An even easier method is to use a wire loop tool. Press this down through a block of clay to make a useful foot or handle. You can bend your own piece of wire for more imaginative shapes.

Feet

Dishes and other pieces may benefit from the support and lift that feet will give them. Bowls and dishes take on additional presence when raised up. It is like being placed upon a pedestal. Feet allow light, air and eye movement around the work. There is also a tension, delicateness and perhaps fragility suggested when an object is balanced this way.

Strength can also be provided by additional supports along the base. Curved slabs will try to straighten out during drying and firing, so dishes made in this shape may need reinforcement to maintain their structural integrity and avoid cracking or drooping.

Slabs, cut shapes, coils or extruded profiles may all be used to give the necessary solutions. It is often a combination of techniques that gives the best result.

Other considerations

The overall form of the work needs to be viewed in the round. In this regard, a banding wheel or turntable will allow you to see it from all sides. It is also important to vary the distances and angles from which you study the piece. When actively engaged in the refinement of form, we are seldom more than an arm's length from it. Closely engaged, we give great attention to particular details, but at the same time the overall effect may be overlooked. For this reason, it is worth deliberately placing yourself across the room to see things from a distance.

When a work seems to be complete, cover it up and leave it overnight. You will probably be surprised in the morning to see things that you missed and wish to alter. Fresh eyes see things more clearly, as your judgement may be better after a good night's sleep. Maintaining moisture content is essential so that you can make any changes. Wrapping things up will allow wet and dry areas to even out and become more uniform, and in any event slower, uniform drying is always a good idea as it will help to avoid cracking.

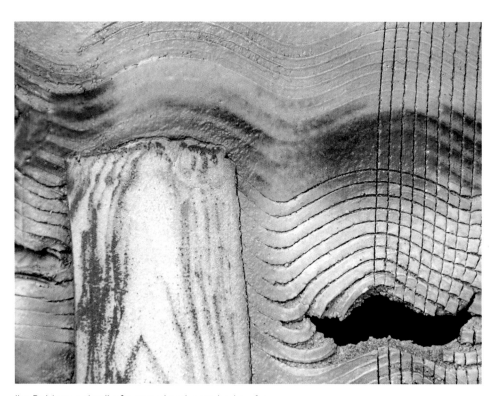

Jim Robison, a detail of a scored and stretched surface.

Christy Keeney's lightly modelled, painted and drawn head. Ht: 33 cm (13 in.). *Photo: Jim Robison.*

Sally MacDonnell, two seated figures, Ht: 38 cm (15 in.). *Photo: courtesy of the artist.*

Chapter 6
Going Larger

Several approaches are open to the maker of larger work.

Multiples

Multiples or repetitions of similar units provide limitless scope. Consider the tile, for example, which will cover walls and floors of any dimension. You could use commercially available tiles. These have been used successfully to paint murals and wall panels for domestic and public spaces. Make your own large tiles and glaze them in groups that create a unified pattern or picture.

School and community groups have approached me for ideas on mural creation. The Peace Garden at the Glossop Community School in Derbyshire is one example. Individual children all needed to be involved, with hands in the clay, yet all the pieces also needed to fit together. The solution was to make several wood frames, identical in size, to contain each person's work. Drawings, impressions, slip painting, textures, hand and foot prints, and modelling in relief could all be explored in an individual clay tile with the certain knowledge that the pieces would stay together. As some tiles were quite heavy, countersunk holes were made for screw-fixing them to the wall.

Jim Robison uses a wood frame to aid tile construction for a public commission.

Wood frames also permit the development of a three-dimensional aspect. A public seating/artwork project in Holmfirth in Yorkshire was built up from slabs pressed against the wood sides of the frames. Some of these were quite deep, and almost cubelike. Hollow backings were made to various depths and covered with a thick slab topping on which modelling and drawing took place. This gave real form and substance to the piece. As this was for a public space, strength was required to withstand wear and tear. The solution was to fill the hollow backing of each tile with a dry mixture of sand and cement before installation on a stone base. This not

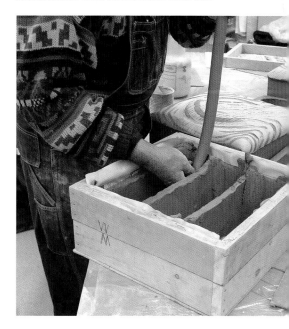

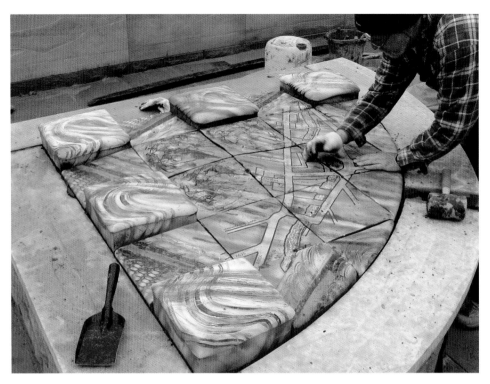

Jim Robison, an installation of a tile artwork, map and seating for Holmfirth in West Yorkshire.

Rope texture is pressed into the clay with a wallpaper roller. *Photos: Ian Marsh.*

only helped support the clay in everyday use, but prevented damage from the unexpected pressures of feet, skateboards and mountain bikes.

Individual tile artworks were made by Ian Marsh using a similar wood-frame technique. In this case a single large sheet is impressed with plastic mesh, ropes and stamps. Painted slips emphasise shapes and movement. This decorated surface is turned face down on heavy paper while sides and divisions between tiles are attached to the back. Reinforcement strips are placed in the middle of each tile to prevent sag during drying and firing. The irregular shapes of adjoining tiles are drawn out and end walls are carefully added without the benefit of wood supports. A thin

Ian Marsh uses a supporting wood frame to construct his deep tile panels.

Ian Marsh cuts one long tile into sections for design purposes and easier firing.

strip is placed against one edge to locate the second one, leaving a small gap in between. A long pointed knife is used to cut between these walls. When firm, holes for wires or screw fixings facilitate wall hanging.

The frame size for your tiles needs some thought. Lines made by edges may interrupt the flow of your design and you may wish to adjust them accordingly. Group working and storage spaces may be issues. Individual boards, damp cupboards (or lots of plastic sheeting) and shelving need to be available.

Ian Marsh's *Triptych* tiles use pressed rope and cloth stencils to create surface patterns. Ht: 76 cm (30 in.). *Photo: courtesy of the artist.*

A Jim Robison garden sculpture made from sections.

Jim Robison and Ian Marsh trial-fit leatherhard sections of a garden sculpture.

The most inflexible detail, however, is kiln capacity, specifically the sizes and number of shelves available. Do not forget to deduct space to take account of the props needed to support the shelf above! Some new bats may be required. I found the purchase of some stacking-plate bats a lifesaver. Each holding a 30 cm (12 in.) tile, they made efficient use of space and reduced the number of firings required.

Assemblies and stacking constructions

Large pieces designed as one but constructed of several individual sections offer another possibility. This method has several distinct advantages. One is that you are able to create substantial

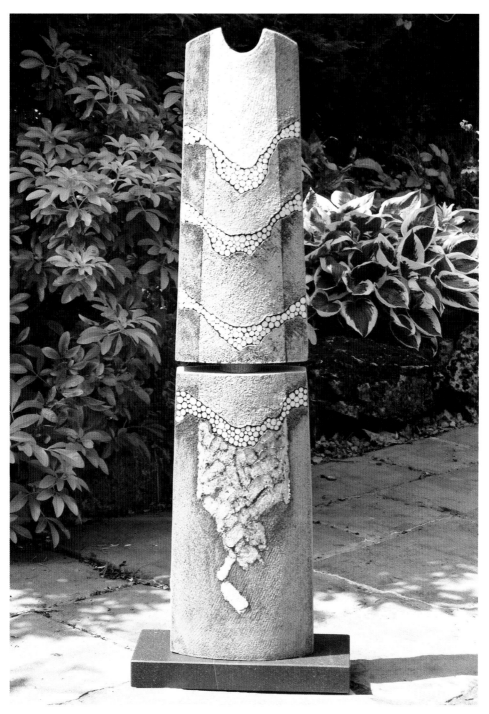

Nigel Edmondson makes joints obvious on his sectional pieces. Small clay discs hold these
sections apart on a supporting pipe. Ht: approx. 1.2m (4 ft). *Photo: courtesy of the artist.*

works without the need for a very large kiln. Another is the weight factor. Smaller individual pieces weigh less and are easier to handle. I have a motto (sometimes ignored) that states, 'You should only make pieces that you can lift.' I often regret ignoring this advice, especially as my studio is separated from the kiln by a rather narrow set of stairs. Size and weight issues are also an important consideration when you have a top-loading kiln, as it is particularly difficult to lower a large piece onto a kiln shelf some distance below.

Smaller sections are also easier to pack up and deliver to exhibitions or installation sites. Nigel Edmondson carefully crafts his garden sculptures to fit into specific plastic boxes or trays he has obtained from a garden centre. Individually wrapped sections are protected from knocks and easily lifted. Boxes can also be stacked several high in the car and similarly on a sack cart for later movement on site.

Assemblies do require careful planning and management throughout the making process. Drawing helps as you design the sections. Wood or other formers will enable you to lay the clay into them (or over them) to make specific sizes and shapes. The joint or meeting surface between pieces must be carefully made and some method of securing the sections together thought about in advance. Stiff paper, card or hardboard (Masonite) patterns help when cutting slabs for a base, which will then fit on top of another section. Trial assemblies of sections can be made when they are leatherhard.

A piece of paper or thin plastic film between sections will prevent them from sticking together while you refine the area where they meet.

There will always be joints to consider; do you try to hide them or make a feature of these necessary seams? It is easier, perhaps, to let them show and design the sections with these lines in mind. Nigel Edmondson makes a real feature of them by inserting a spacer between the units, creating a strong shadow between pieces.

When wishing to disguise a join, think of a socket approach, where one piece fits into or over another. Karin Hessenberg creates sockets to lock pieces together while also creating shadows by overlapping sections. You must have enough strength in side walls to support the piece above, and on the whole I prefer flat areas for kiln-shelf contact, but you can also create surface irregularities and shadows that distract the eye from an obvious straight line.

It is important to have all pieces fairly close to each other in moisture content when making trial assemblies. If not, you may find that they do not fit together later. Clay shrinkage is about 10% or more from start to finish, and about half of this occurs in the drying stages. Templates for tops and bottoms will make sure that they started out the same, but there are inevitable changes taking place as you develop your ideas. If anything, tops tend to dry quicker and give misleading impressions of fit. Slow this down and try to keep the sides apart. A slab top will help, or a temporary wedge, or else pack the interior with paper or soft cushion-type foam. However, you should remove this material before firing or else expect to have unpleasant smells and fumes.

Tops seem to shrink more during firing too. The base slab is held in place by the weight of the piece and is restricted in movement, both as a wet slab against a board during drying and subsequently

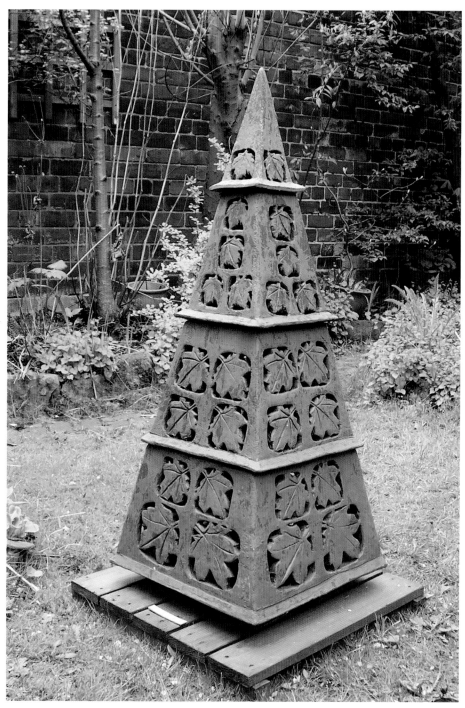

A Karin Hessenberg garden sculpture made of stacked sections. Ht: approx. 1.2 m (4 ft). *Photo: courtesy of the artist.*

by friction against the kiln shelf. Try to loosen the piece from its board during making, or place it on paper to allow movement. The paper wrinkles and can be pulled off when leatherhard. Wood slats will aid drying and permit movement too. Use placing powder, silver sand or grog on the kiln shelf to reduce friction during the firing.

Fired sections need to be secured for display. Bolts, threaded metal rods or glue and resins are the usual methods. Pre-planning will make this easier, as you can cut holes in leatherhard clay much easier than in the finished product. If you are able to pass a threaded bar all the way through the work, it can be easily anchored down to any base. Nuts and washers on top will pull down and hold the entire stack together. Cover these with a clay lid for hidden security. I rely on this approach to secure larger works.

Many modern adhesives will provide strong bonding for ceramics. Take advice from manufacturers. Two-part epoxy mixtures are incredibly strong and durable. Others include several used by builders, which come in tubes, fill gaps and may be applied with a mastic (caulking) gun. Silicone types, such as the sealants used around windows, remain flexible and come in a variety of colours. I have used the cans of foam on occasion and have been surprised at how strong and long-lasting this material is. We have two 152 cm/5 foot tall pieces in the garden that were stuck onto a large paving stone 10 years ago with this stuff, and they remain fast in spite of the gale-force winds we get during our Yorkshire winters.

Nigel Edmondson uses a metal base plate with a vertical pipe welded onto it. This base plate is covered by a stone which has a hole for the pipe, and the clay elements just slide over the pipe. This is ideal for temporary exhibitions and garden shows, where he sells much of his work. For works intended to stay outdoors, use stainless steel, brass or galvanised metal for longevity. High-fired stoneware is the most durable and frostproof, but vitrified and/or glazed earthenware will do well in sheltered situations. Be sure that all elements drain properly, so that pools of water do not collect and freeze. Water, in the form of expanding ice, will crack most materials!

A Jim Robison base section of stoneware sculpture, being anchored on a paving stone with a threaded bar. *Photo: courtesy of the artist.*

A Jim Robison sculpture installed in a small garden. Ht: 2.5 m (8 ft). A stainless-steel threaded bar holds this in place. *Photo: courtesy of the artist.*

Individual pieces

Monolithic or singular pots and sculptures are made and fired as one piece. Determined by the size of your kiln (or one you have access to) and your ambition, it can be an enjoyable challenge to attempt work beyond your usual scale, or 'comfort zone' as it might be called. I remember the jump up to 12kg (25lb) of clay on the potter's wheel, and how the increase in volume made the usual bowls and cylinders so much easier to throw. You may find this type of experience brings similar rewards.

Start with slabs a bit thicker than usual, so that the weight of the work is well supported. Remember that clay, the raw material, has considerable crushing strength, but much less under tension. In other words, you can build vertical walls that are self-supporting, but expect problems in horizontal areas. Wide pieces will probably need support, not only during the making but also during the firing as well. Coarse clays will generally have greater strength and, due to their lower shrinkage rates, encounter fewer problems in drying and firing. Those reinforced with fibres will allow more extravagant shapes. These clays hold together well and any cracks are more easily repaired. Having said that, when fired, the fibres are burned away and the clay seems a bit weaker. I prefer the touch of normal clay; I also don't wish to spend the time making slip to blend fibres into; and I can't justify the additional expense of the ready-made special bodies. But those who use fibre clay often swear by it, so try it for yourself.

All clay work, but particularly larger coil and slab pieces, needs to be done in stages. Based on moisture content, work is built up gradually as the base and lower sections dry out enough to support the next activity or the weight of additional pieces. I start with substantial slabs, rolled out, smoothed down and left to dry naturally to leatherhard stiffness. If you cover them with newspaper and plastic, they will still dry, only more slowly. Remember to make them a bit larger than needed, so drier edges can be trimmed and joints made in moister clay. Rapid drying can be encouraged with a hairdryer, paint stripper or gas torch, although I generally restrict myself to a light touch here – just enough to dry surface slips so they can be touched. It is best to keep slabs at a uniform moisture content, and this is difficult to control when heat is applied to small specific areas.

While still soft, bend slabs into shapes and place them in or over supports to keep the desired shape. Continue drying until leatherhard. I tend to see slab-building as a bit like carpentry or joinery. Sides are made, cut to size and then joined together when fairly stiff. I use curved formers to hold the clay sides until firm, and support them while they are being raised into a vertical position on a slab base. Two halves may be given additional strength during this process by the addition of temporary splints (thin strips of wood held in place by coils of clay). I find that large sections can be built horizontally and erected successfully in this way. Curved slabs, or ones with right angles built in (think of two sides of a box), will be nearly self-supporting if they have dried out enough.

Thixotropy is characteristic of clay. Usually associated with a slip's ability to change fluidity, it also affects the way wet clays maintain a given shape.

A Jim Robison large garden stoneware vase. Ht: 1.2 m (4 ft). *Photo: Ian Marsh.*

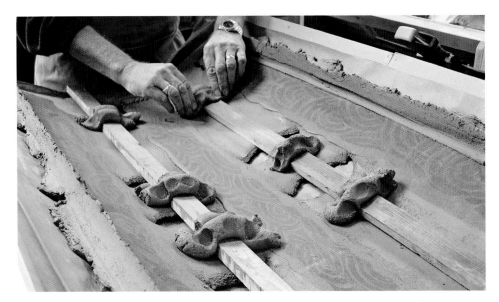

ABOVE Wood slats, held by clay coils, provide support when lifting large slabs into a vertical position.

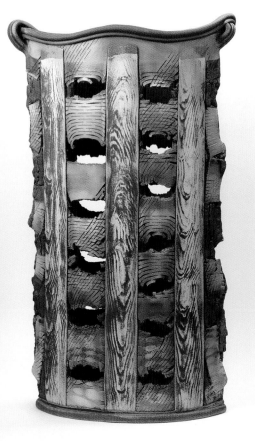

LEFT Jim Robison, vase. Ht: 1 m (39 in.). A profiled coil base, a substantial rim and coil-reinforced edges give the necessary strength to the open latticework of the sides. *Photos: Ian Marsh.*

Undisturbed slips may appear quite thick and solid yet become very fluid when stirred. Undisturbed slabs will feel firm and hold their shape quite well. Pick them up and bend them around and they become much more floppy. It seems as if they remember liquid origins and become softer. So try to limit the movement of pieces you have under construction until the seams are secured. If you're not careful, your form may go weak at the knees!

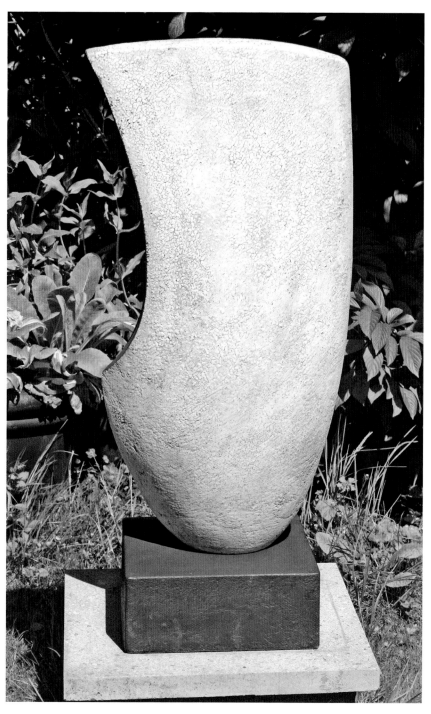

RIGHT Alan Foxley uses large slabs to construct his sculptures. Ht: approx. 1 m (39 in.). *Photo: courtesy of the artist.*

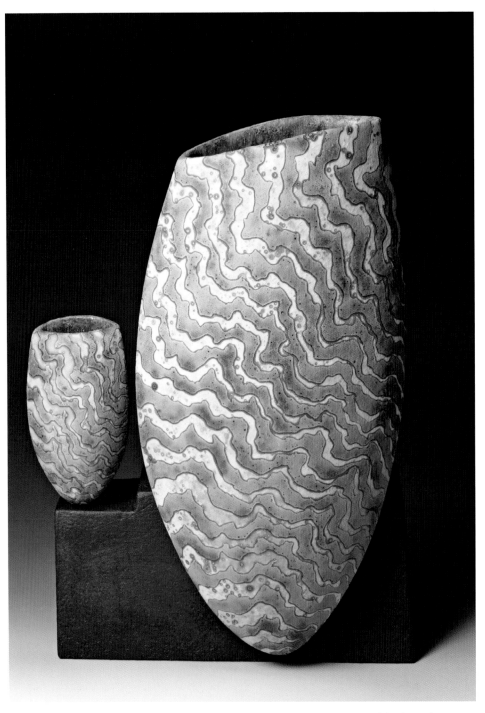

Double Vessel Form by Peter Beard. Ht: 38 cm (15 in.). Peter Beard uses a combination of overlapping glazes to create rich and varied surfaces. *Photo: courtesy of the artist.*

Chapter 7

Applying the Glaze

In practice, there is little difference between glazing slab items and glazing any other form of ceramic object. It may be true that the irregular shapes made with slabs create some difficulties when compared with the usual 'round pot'. However, all glazing sets out with three objectives in mind: to provide colour, texture and, when appropriate, functionality. One glaze might do the whole lot, or there might be a variety of surface and colour areas applied to meet the joint goals of function and decoration. Functional ware needs an internal surface that is waterproof and easy to clean. A smooth glaze melted on the internal surface will seal the clay, making it easy to wash and water-resistant, an important factor given that otherwise it might leak through the base and spoil some valuable piece of furniture.

The usual practice is for work to be bisque-fired prior to glazing. The bisque firing renders the piece hard, but still absorbent. This means that the liquid content of the glaze is drawn into the body, bringing the glaze materials onto its surface. The fired temperature of the bisque ware (usually around 900 to 1000°C/1650 to 1830°F) will affect the porosity of the clay, with lower temperatures having the greatest absorption rate. Glazes need to be mixed with more or less water, according to this absorption rate and the method you use to apply the glaze.

After bisque firing, most objects are dipped, brushed, poured or sprayed with one or more glazes. Underglaze colours or an oxide wash are sometimes applied prior to glazing. It is of course possible to do a combination of several techniques.

Pouring and dipping

Pouring and dipping will build up glaze layers very quickly. Try testing the qualities of surface and strength of colour by single- and double-dipping. Pouring one glaze over another is also effective and will make additional colours where overlapping occurs.

A good glaze coating will be about the thickness of good-quality writing paper. Test this by scraping a bit off with a fingernail and touching it up with a brush afterwards.

Pouring and dipping will give the most even overall coating. This is important in functional ware, although care must be taken to avoid over-thick applications. Thick applications will run during firing and, in extreme cases, melted glaze will fuse the piece to the kiln shelf as it cools.

Thick glazes may also stress the body if they do not fit exactly (with 'fit' meaning the glaze expansion and contraction rates that occur during firing match or are close to those of the clay itself). I found that the bases of several small vases and jugs cracked right off when thick interior glaze refused to allow

the pot to shrink further during cooling. Taking too long with the glazing process caused this over-thick application. Too much time taken with the filling up, with rotating the pot and pouring out excess glaze encouraged the build-up of glaze in the base as water soaked into the body. To solve the problem, I added more water to the glaze, making it thinner. I also dampened the piece with a sponge, and in some cases even pour water in and out of the vase first to reduce its absorbing capacity. If the inner glazed surface stays wet, then you may need to let the piece dry out before adding glaze to the outside of it.

Brushing

Brushing is best done with a soft, wide brush, and you will generally need to apply several coats. Because the glaze quickly dries out as water soaks into the clay, it will be difficult to achieve an even, uniform effect. Be careful when loading up the brush, and lay it onto the surface in broad strokes. Apply each subsequent coat in a different direction (side to side, up and down, and diagonally). Try not to scrub off the previous coat in the process. Some purchased glazes are specifically designed to be 'brush on' and are easier to use. They are thicker than those mixed to be poured and dipped. You can thicken ordinary glazes by allowing them to stand overnight, then pouring off surplus water that collects on top. If brushstrokes seem unavoidable, try soaking a small sponge to print the glaze over the surface.

Spraying

Spray glazing has both advantages and drawbacks. It requires some equipment:

an air compressor and a spray gun, for a start. A dust mask is also essential and a spray booth is useful, although I tend to spray pieces out of doors on nice days. Small compressors are now relatively inexpensive and readily available. An ordinary automotive spray gun will do the job. I use a top-feed spray gun (one with the cup above the gun) as the glaze is then gravity-fed (not drawn up from a bottom cup by passing air) and the gun is easier to wash out. Various gun and nozzle sizes are available, depending on the scale of tasks you plan to undertake. In automotive terms, mine would be a 'detail' gun, rather than one of the larger models. Smaller airbrush types are available for fine work, but you must then put all glazes and stains through a 100 mesh or finer sieve to avoid clogging its fine nozzle.

Spraying requires a rather thin glaze mixture, and several coats are needed for an effective covering. It is best to build up thin layers, not trying to do it all in one shot. If you just point and shoot, the glaze will quickly build up and begin to run down the surface. Move the spray gun back and forth while going around the work. It is important to be systematic in your coverage of the piece. Work from side to side and from top to bottom to be sure that the glaze goes on evenly and in sufficient quantity. Once the first layer is on, it becomes difficult to judge the thickness of application and the specific areas covered, so you must remember where you have been.

One great advantage of spraying is the ability to blend glazes and colours into each other. Layers may be applied with great delicacy. With care, details can be glazed with considerable precision. Masking, shading, stencils and simply

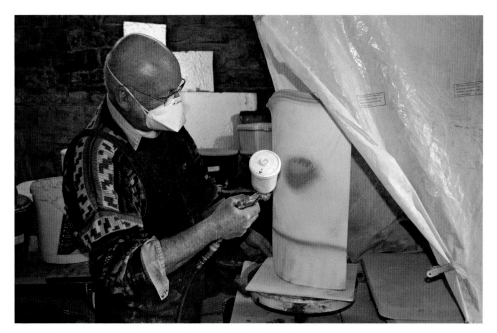

Jim Robison uses a small spray gun for controlled applications.

wiping off excess glaze will help you develop patterns and designs.

It is worth mentioning that you can combine any or all of these approaches – dipping, pouring, brushing and spraying – in the same work. Combining methods – say, pouring the interior, then brushing and spraying the outside – may be an excellent solution.

Raw glazing

Some makers find that they prefer to bypass the bisque stage completely and apply glazes directly to the unfired work. Historically, this approach was common practice among the country potters. They poured white slip over the leatherhard red clay ware, and followed this with a similar coating of glaze before its one and only firing. Glazing was done in stages, with interiors poured first. The pots were then set on one side to dry, back to leatherhard, before glazing of the exterior.

Glazing raw has some risks. Unfired pieces remain quite fragile and must be handled with care. Applying wet glaze to damp clay can make it soften, so try not to get it too wet. If moisture saturates dry clay, it can cause cracking or a complete disintegration of the piece. A very wet layer of glaze may cause unfired slips to loosen their grip on the clay body. When using a spray gun, apply several light layers to avoid bubbles and lifting of previous coatings.

Remember, too, that if anything goes wrong, washing the glaze off dry or leatherhard clay is a very difficult thing to do as the clay surface goes along with it. I gently rub off the unwanted glaze with a dry sponge or a coarse kitchen pan scrubber. Just take care not to rub away slips and details at the same time. **It is important to wear a mask to avoid inhaling the dust.**

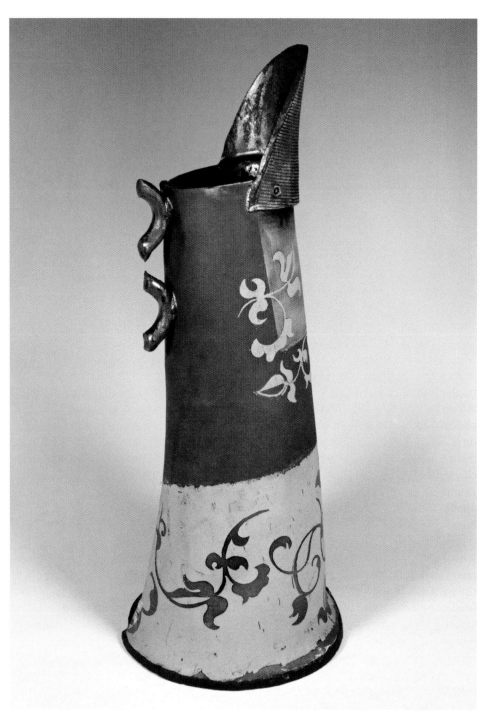

Sarah Dunstan uses glazes on the interior of these pieces, but relies on porcelain slips for the surface decoration. Ht: approx. 36 cm (14 in.). *Photo: courtesy of the artist.*

In spite of the risks, there are certain advantages to raw glazing. First is the reduction in effort and time taken to pack and fire the kiln. Larger pieces are difficult to move, so being able to load the kiln just once instead of twice feels great. Secondly, in these days of high energy costs and environmental concerns, one less firing has real savings attached to it. The 'once firing' involves a combination of bisque and glaze firing schedules. That is, several hours are needed for gentle drying out and warming in the early stages up to the usual bisque-fired temperatures; then, instead of shutting down, just continue on until the final glaze temperature is reached, before shutting off and cooling as you would a normal glaze firing.

Raku and smoked surfaces

The usual process is rapid firing, followed by plunging the hot pot into combustible material and cooling it in water (see the photograph of work by John Wheeldon on p. 52). The combination results in lustrous colours and heavily smoked clay where unglazed surfaces are used. Jacqui Atkin does not use glaze, but applies colours as slips which are then burnished. After bisque firing, she coats them with a thick 'resist' slip applied with a brush. Surface patterns are then created by stencils and wax resist. Next, the whole piece is glazed to seal areas from the smoke effect. Once fired and smoked, the glaze and resist base is removed and the work is finished off by being polished with beeswax.

This is a topic discussed in many books and reference articles (for example, Tim Andrews's book *Raku* and Jane Perryman's book *Smoke Firing*) and these should be referred to for more detail on the subject.

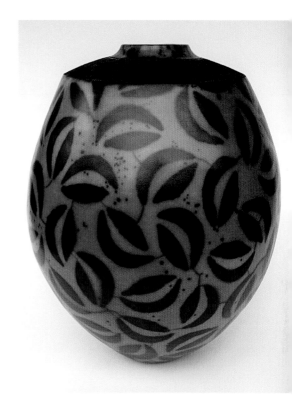

Jacqui Atkin's work, made from flattened coils, shows the effects of burnished slips that have been smoked and then waxed. Ht: 50 cm (20 in.). *Photo: courtesy of the artist.*

Other options

For the non-purist numerous 'unfired' surfaces could be considered. Sculptural or non-functional work might benefit from a mixed media approach. Wax is available in clear, coloured and even metallic forms. Sanding, polishing or sand-blasting could bring about the desired surface. Graphite, inks and paint might be applied. Current ceramic catalogues list many 'unfired' or 'low temperature' coatings as alternatives to the usual glazing and firing processes.

Chapter 8

Drying and Firing

You should always be aware of the slab and its treatment from the very outset. The pressure of rolling out seems to give these sheets a memory, and during the drying phase there is a tendency for clay to try and return to its flat historical roots. Of course you may wish the sheet to remain flat, in which case be aware that if you pick up the slab and thoughtlessly bend it in the process, it will remember this abuse and promptly curl up again as it dries.

When rolling out by hand, it is common practice to turn over the slab during the rolling process, as this will help it to stretch evenly on both sides. However, avoid picking it up more than is necessary unless stretching and distortion are deliberately sought. With a larger slab it is often better to sandwich the clay between boards and flip it over instead of lifting it by one edge.

Drying during making

Drying starts as the slab is being made. Controlled drying is essential to the making and continues until fired. By their very nature, slab techniques often require assembly of several pieces of clay. And they are seldom of the right consistency when freshly made and very soft.

I have several sheets of hardboard (Masonite) on which to put fresh slabs after making. Some use paper-covered plasterboard or similar sheets. If you place a slab on absorbent material, boards or paper, air will dry the top surface while the boards take water from below. It is easy to forget this two-sided fact when covering up slabs for later use. It is always best to keep a regular check on the slabs and to use them as they reach the appropriate stage of dryness and stiffness. You must wrap both board and clay if moisture is to be retained for any length of time.

Throughout the making process, it is important to allow drying where stiffness and support are needed, while keeping surfaces soft and wet enough to join fresh clay and modify the form as required. It is generally thought best to work in stages, building up as lower sections dry out naturally. This might mean a delay, and many potters overcome this by working on several pieces at the same time. I generally have several on the go at any one time.

Rapid drying

Forced drying is possible, of course, using a hairdryer, electric paint stripper or gas torch. Some of the grogged and fibre-clay bodies seem to take this rough treatment in their stride, and it certainly speeds up the process. Just remember the risks involved. The clay may feel dry to the touch but still be very wet inside and not as strong as expected. And it goes without saying that **you must assess the danger of fire when using any heating appliance.**

Slab pieces placed on one another ready for re-rolling in the slab roller.

I have made the mistake of attempting to rapidly dry slabs on wooden boards or rolling cloths or even newspaper, with predictable results. Nowadays I keep a fireproof cement-based board in the studio to put slabs on when this kind of rush is deemed necessary.

Drying finished work

Once the work is completed, attention to the drying detail needs to be maintained. A vast amount of shrinkage takes place at this stage, and uneven drying can cause major problems as joints and surface variations come under stress. Thin areas will dry and shrink first, while thick sections remain damp and resistant to movement. A flat base will have little air circulating around it, so remain moist while the top dries out quickly. In this example, slab vases will try to close up at the top, while the base refuses to allow the sides to move in at this point.

As the sides dry out, they can develop the appearance of an old man with no teeth, sucking his cheeks in. I doubt that this is what you have in mind.

To control this, place the work on an absorbent surface, to help remove water from below while keeping the top initially wrapped up. I find it also helps to push the sides out from the inside, making them slightly proud at the start. When firm, lift larger work onto wood slats to allow air circulation around the base. You may wish to place some soft foam or a ball of newspaper inside the work to hold the sides apart while the base catches up in this drying sequence. If you use rigid material, such as wood or metal, be sure to remove it as the clay starts to dry. Left for any length of time, this may become stuck fast as the clay shrinks around it, even cracking the work.

Remember to rotate the work as it dries. Draughts, heating systems and even sunlight through a window will surprise

Pressure causes the slabs to stretch and tear. Excessive tears and cracks may need repair.

you with distortions as drying takes place. I sometimes use bubble wrap to further protect and insulate work from sunshine moving over the studio roof windows.

It can be quite a struggle to create and then maintain the desired form through this drying period. Generally speaking, the more gently and slowly drying takes place, the less warping and cracking are likely to occur. A light spray of water and a bit of newspaper with plastic on top may be necessary to help even things out. Smooth clays have the most shrinkage, and porcelain is at the top of the list with perhaps as much as a 20% loss. After all your efforts, this is really not the time to rush.

Repairs and re-wetting

Cracks and accidents sometimes occur in spite of our best efforts. If the piece is still leatherhard, then the repair is fairly straightforward in that you can wet the edges, score the surfaces and rejoin sections, or else work softer clay into the gap. Once the item is bone dry, this task becomes a bit more problematic, as the clay structure is now very brittle and may collapse completely if suddenly saturated with water.

There are various preparations that help with repairs. Some potters mix vinegar with dry clay for a thick joining mixture that seems to have less shrinkage than water-based slip. Keith Rice-Jones uses what he calls 'magic water' to secure joints (see recipe on p. 47).

Potters' suppliers have what are called 'stopping powders', in white and terracotta colours, which can be mixed with water and used for dry and even bisque-ware cracks.

My own stretched clay dishes, which have been rolled and re-rolled (treating them to what Ian Marsh calls 'clay abuse'), are subject to stress cracks during drying. These can be reduced by

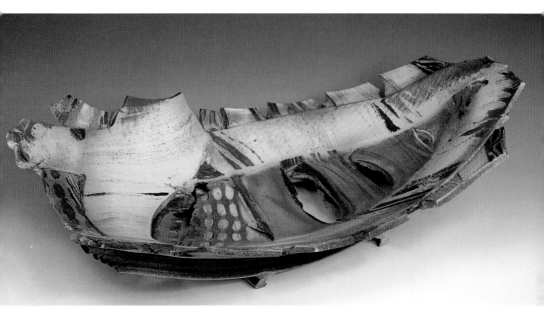

A Jim Robison slab dish. W: 50 cm (20 in.). *Photo: Ian Marsh.*

careful support during the drying stages to reduce the effects of gravity (leaving the dish inverted over hump moulds until quite firm, and then propping up the outer edges after turning it over). Some cracks are acceptable, but when beyond my tolerance, they get filled in. The normal clay body will go some way, but often cracks reappear on drying. Recently, I have begun working grog particles into a bit of soft fibre or paper clay between the fingers, moistening the crack edges with a paint brush, and then poking this mixture deeply into the crack with a knife blade. It works a treat. The fibres hold the clay together while the grog reduces the shrinkage. If the repair is of a different colour, mix a little clay body with water and cover the spot with this slip.

When really substantial repairs are needed to dry pieces, it is usually not worth the effort, as repairs tend to be quite weak if edges are simply wet and bits stuck together again. To be really successful, the whole piece needs to be brought back to a leatherhard stage and a workable consistency. We are always told that this isn't really feasible because water rushes between the dry clay particles and they fall apart. You can confirm this by putting a piece of dry slab in a bowl of water and watching what happens! However, if you are determined and also willing to be patient, it is possible to bring the clay around to a workable state. Cover with a damp cloth and spray it regularly as the water is gradually absorbed into the piece over a period of days. Keep tightly wrapped in plastic between sprays and do not oversaturate the cloth in the process. This situation is where users of fibre clays have the advantage, as these have the capacity for strong reattachments even when completely dried out.

Firing the work

Bisque firing

As with glazing, there is little to differentiate slab ware from any other work in the kiln. Irregular shapes may pose some difficulties in packing, as odd sizes abound where production potters pride themselves on making specific shapes to fit efficiently together under a four-, six- or twelve-inch prop.

The universal concern is moisture. Be sure that the work is dry throughout, not just dusty on the top. Place your hand on the bottom of the piece and see if it is cold. If you are in a warm room, this is a sure indication that water evaporation is still taking place. Leave it a little longer, place the work in a warm place for a day or two, then fire the kiln with a gentle drying cycle at the start or risk the consequences.

Firing larger pieces in my gas kiln, I gradually warm things up to 100°C (212°F) on one burner overnight (approximately eight hours) before adding the other three, one at a time. In the electric kiln, smaller pieces are brought up to this temperature over three or four hours with the vents open.

Atmospheric water turns to steam and will generate tremendous pressure if trapped inside a ball of clay. However, heeding these two simple words of advice can stop most explosive problems of this nature: slow down! Air pockets are not the problem they are made out to be. Rapid firing is the real problem, as the steam simply needs time to work its way out of the clay. Atmospheric moisture leaves first, and then, as the temperature climbs to red heat, water that is chemically combined with the clay is also driven off. This is generally completed at around 650°C (1200°F). Electric kiln vents are then usually closed to preserve heat and bisque firing continued up to 950 to 1050°C (1740 to 1920°F).

Glaze firing

Glaze firing can generally proceed at a more rapid pace than bisque, as there is only residual water from the glazes to remove in the early stages. A rise of 100°C or more per hour is not uncommon. It is possible to do this too quickly, however, as overenthusiastic raku potters have discovered to their cost. Freshly glazed ware, not allowed to dry, may explode with a sound like popcorn when the burner is turned up too quickly. In normal kilns, the results are not usually so dramatic, but steam can still loosen a glazed surface. This creates potential for crawling glazes and droplets melted onto kiln shelves.

An alternative to the two-part process of a bisque firing followed by a glaze firing is the 'once-fired' approach. Glazes can be applied to the greenware either in a leatherhard or dry state. After drying, simply fire the work just once to the appropriate glaze temperature. The initial warm-up and early stages of the firing must conform to a bisque-firing schedule, so that water can escape and carbon matter in the clay burns out before the glazes begin to melt. Thereafter, just continue the firing to the temperature of your choice or until the selected pyrometric cone has slumped to indicate that the correct amount of heatwork has been accomplished.

For kilns and firing advice, there are a number of good reference sources available (see Bibliography).

Bibliography

Andrews, Tim, *Raku* (A&C Black, London, 2005).

Bailey, Michael, *Glazes Cone 6* (A&C Black, London, 2001).

Baird, Daryl, *The Extruder Book* (The American Ceramic Society, Ohio, 2000).

Bivar-Segurado, Dominique, *Wall Pieces* (A&C Black, London, 2009).

Bruce, Susan, *The Art of Handbuilt Ceramics* (Crowood, London, 2000).

Cohen, David and Anderson, Scott, *A Visual Language* (A&C Black, London, 2006).

Connell, Jo, *Colouring Clay* (A&C Black, London, 2002).

Doherty, Jack, *Porcelain* (A&C Black, London, 2002).

Frazer, Harry, *The Electric Kiln* (A&C Black, London, 2006).

Hamer, Janet and Frank, *The Potter's Dictionary* (A&C Black, London, 2004).

Hardy, Michael, *Handbuilding* (A&C Black, London, 2004).

Hessenberg, Karin, *Ceramics for Gardens and Landscapes* (A&C Black, London, 2000).

Lou, Nils, *The Art of Firing* (A&C Black, London, 1998).

Mansfield, Janet, *Ceramics in the Environment* (A&C Black, London, 2005).

Mathieson, John, *Raku* (A&C Black, London, 2005).

Mattison, Steve, *The Complete Potter* (Barron's, London, 2003).

Minogue, Coll, *Slab-built Ceramics* (The Crowood Press, London, 2008).

Olson, Fred, *The Kiln Book* (A&C Black, London, 2001).

Pancioli Diana, *Extruded Ceramics* (Lark Books, NC, 2000).

Perryman, Jane, *Smoke Firing* (A&C Black, London, 1999).

Peterson, Susan, *Working with Clay* (Laurence King, London, 1998).

Rhodes Daniel & Robert Hopper, *Clay and Glazes for the Potter* (3rd edn.) (Krause Publications, 2000).

Robison, Jim, *Large-scale Ceramics* (A&C Black, London, 2005).

Rogers, Phil, *Ash Glazes* (Black/Chilton, London, 2003).

Tristram, Fran, *Single Firing: The Pros and Cons* (A&C Black, London, 1996).

Triplett, Kathy, *Handbuilt Ceramics* (Lark Books, New York, 2008).

Glossary of Terms

Alumina (Al_2O_3). An oxide of aluminium. Supplied as calcined alumina or alumina hydrate.

Ball clay Highly plastic refractory clay. Fine-grained sedimentary clay.

Biscuit or bisque Pottery which has been fired to an insoluble, but porous state.

Body A mixed or prepared clay that forms the structure of a pot.

China clay or kaolin A white clay found in porcelain and stoneware clay bodies, and a useful addition to slips and glazes.

Deflocculant A catalyst or electrolyte added to a clay-and-water slip to reduce the amount of water needed for fluidity. Sodium silicate and soda ash are usually used.

Earthenware Low-fired pottery, usually red clay and porous in nature, fired to below 1200°C (2192°F).

Greenware Dry unfired clay ware.

Grog Crushed fired clay added to plastic clay to increase strength and reduce shrinkage.

Kidney A kidney-shaped tool made of flexible steel for scraping or of stiff rubber for pressing and smoothing clay.

Leatherhard Describes clay that is dry enough to be firm but still soft enough to be worked.

Plastic When applied to clay it means that the clay is soft enough to be shaped but also capable of retaining its shape.

Porcelain White clay body, usually translucent when thin. Fired to 1260°C (2300°F) and above.

Refractory Resistant to heat, capable of withstanding high temperatures in the range of 1300°C (2372°F) and higher.

Slip Clay in a very liquid state. A suspension of clay in water.

Slurry A mixture of clay and water used for joining slabs.

Stoneware Pottery which has been fired to a hard and vitreous state usually above 1200°C (2192°F).

Vitrify The fusion or melting of a body during firing.

Wedging The cutting and kneading of clay to eliminate air and create an even mix.

List of Suppliers

UK

Bath Potters Supplies Ltd.
Unit 18, Fourth Avenue
Westfield Industrial Estate
Radstock
BA3 4XE
Tel: 01761 411077
Web: www.bathpotters.co.uk

Ceramatech Ltd
Units 16 & 17 Frontier Works
33 Queen Street
Tottenham North
London N17 8JA
Tel: 0208 885 4492
Web: www.ceramatech.co.uk

CTM Potters Supplies
Unit 10A, Mill Park Industrial Estate
White Cross Road
Woodbury Salterton
EX5 1EL
Tel: 01395 233077
Web: admin@ctmpotterssupplies.co.uk

Northern Kilns
Pilling Pottery
School Lane
Pilling, Nr Garstang
Lancashire
PR3 6HB
Tel: 01253 790 707
Web: info@northernkilns.com

Potclays Ltd.
Brick Kiln Lane
Etruria
Stoke-on-Trent
ST4 7BP
Tel: 01782 219 816
Web: www.potclays.co.uk

Potters Connection Ltd.
PO Box 3079
Stoke on Trent
ST4 9FW
Tel: 0782 598 729
Web: www.pottersconnection.co.uk

Scarva Pottery Supplies
Unit 20
Scarva Road Industrial Estate
Banbridge
Co. Down BT32 3QD
Northern Ireland
048 40669699
Web: www.scarvapottery.com

Valentine Clays Ltd
The Sliphouse
18-22 Chell Street
Hanley
Stoke on Trent
ST1 6BA
01782 271 200
Web: www.valentineclays.co.uk

USA & Canada

American Art Clay Co., Inc.
6060 Guion Road
Indianapolis, IN 46254
USA
Tel: (800) 374-1600
Web: www.amaco.com

Axner Pottery Supply
490 Kane Court
Oviedo, FL 32765
USA
Tel: (800) 843-7057
Web:www.axner.com

Bailey Pottery Equipment
PO Box 1577
Kingston, NY 12402
USA
Tel: (845) 339-3721
Web: www.baileypottery.com

Laguna Clay Co.
1440 Lomitas Avenue
City of Industry
CA 91746, USA
Tel: (800) 452-4862
Web: www.northstarequipment.com

Mile-Hi Ceramics
77 Lipan
Denver, CO 80223
USA
Tel: (303) 825-4570
Web: www.milehiceramics.com

North Star Equipment Inc.
PO Box 189
Cheney, WA 99004
USA
Tel: (509) 235-9200
Web: www.northstarequipment.com

Peter Pugger Mfg Inc.
3661 Christy Lane
Ukiah, CA 95482
USA
Tel: (707) 463-1333
Web www.peterpugger.com

Skutt Ceramic Products
6441 S.E. Johnson Creek Blad
Portland, OR 97206
Tel: (503) 774-6000
Web: www.skutt.com

Tuckers Pottery Supplies Inc.
15 West Pearce Street
Richmond Hill
Ontario, L4B1 H6
Canada
Tel: (800) 304-6185
Web: www.tuckerspottery.com

AUSTRALIA

Walker Ceramics/Feeneys Clay
2/21 Research Drive
Croydon 3136
Victoria
Tel: 03 87616322
Web: www.walkerceramics.com.au

Index